THE DARLINGTON TRANSPORT COMPANY

JOHN CARTER

AMBERLEY

First published 2018

Amberley Publishing
The Hill, Stroud
Gloucestershire, GL5 4EP

www.amberley-books.com

Copyright © John Carter, 2018

The right of John Carter to be identified as
the Author of this work has been asserted in
accordance with the Copyrights, Designs and
Patents Act 1988.

ISBN 978 1 4456 7270 0 (print)
ISBN 978 1 4456 7271 7 (ebook)

British Library Cataloguing in Publication Data.
A catalogue record for this book is available from
the British Library.

Origination by Amberley Publishing.
Printed in the UK.

Introduction

Darlington Transport Company (DTC) was formed as a consequence of the Transport Act of 1985, which required owning councils to set up an 'arm's length' company to take over bus operations as part of the government's desire to deregulate the bus industry and open it up to competition.

The provision of public transport by Darlington Borough Council can be traced back to 1902, when they purchased the horse tram operation of the Imperial Tramways Company. In 1903 this was shut down and an expanded, electric tramway system was opened in 1904.

Trams were withdrawn by 1926 to be replaced by a trolleybus operation. These, in turn, were then gradually replaced from 1950 by motor buses, with the last trolleybuses being withdrawn in 1957. Motor buses were initially Guy Arabs of both single-deck and double-deck types, with Roberts, and then Roe, being the preferred bodybuilder.

In the 1960s, Daimler buses entered the fleet, and started a long association with the fleet. The last double-deckers purchased for the Corporation fleet arrived in 1964 and not until 1990 were any further double-deckers purchased. After 1964, the Corporation purchased only single-deckers, with Daimlers being the choice until the last batch entered the fleet in 1972. After this, Seddon, Leyland, Dennis and Ward products entered the fleet. The last double-deckers were withdrawn in early 1981, and at that point the fleet comprised only single-deck, dual-door vehicles that operated an exact fare system with coin-drop hoppers so the driver didn't handle any cash.

Corporation buses kept within the town boundaries, with out-of-town routes being mainly provided by United Automobile Services, which was also based in Darlington, and this remained the case until 1986. The 1985 Transport Act was due to come into effect from 26 October 1986 and this was when DTC started trading. United had made their intentions to compete on Darlington town services clear, and indeed the first services were introduced in August 1986, slightly ahead of deregulation day itself – this being allowed in certain circumstances.

After deregulation, United quickly expanded their minibus network in the town to cover most, but not all, areas. DTC responded by expanding out-of-town services to Newton Aycliffe, Hurworth, Richmond, Teesside and

later to Newcastle and the Metro Centre. DTC also diversified into private hire, tours and day trips with a dedicated department. There were also some other smaller-scale activities such as self-drive hire minibuses and, for a while, a contract to supply some vans and pick-up trucks to the council.

By the start of the 1990s, a period of stability was reached, and there was little in the way of further competition between United and DTC. This was all to change in 1993 with the arrival of a new company, Your Bus. Your Bus was set up by ex-United employees and ran on routes that mirrored United's minibus routes. United responded by drafting in more minibuses to run as 'duplicates' and expanded the number of services they operated. DTC was caught up in the middle of all this as, although Your Bus were competing with United services, those United services were competing against DTC. As a result, Darlington became choked with minibuses all chasing the same passengers. DTC responded by introducing some new routes in town and moved towards more minibuses themselves – not only as a way of penetrating some narrower streets, but also to reduce operating costs. Additionally, DTC later expanded their out-of-town operations to hit back at United.

Clearly the situation was not financially sustainable; United had the muscle to operate in Darlington at a considerable loss but DTC didn't and, despite other activities, DTC's town services were still a core part of the business.

In the summer of 1994, DTC, in the light of deteriorating finances, was put up for sale by the council. Stagecoach, who at this time were expanding, were known to be interested, and many of the staff favoured them as having the muscle to take on United.

In the end it was Barnsley-based Yorkshire Traction that submitted the biggest bid by far, and the council was duty-bound to accept the best deal. However, Stagecoach announced they were coming anyway. In light of this, Yorkshire Traction backed out and all other interest fizzled out. With no buyer in the wings, it seemed to most staff that DTC would fail. Like many others I felt that the only way to secure continued employment was to join Stagecoach. We had already been told that the bank would only guarantee DTC's future until a buyer was found. It was with a heavy heart that many staff members moved on to Stagecoach and, unfortunately, the inevitable happened, and DTC went out of business.

Ironically, Yorkshire Traction themselves sold out to Stagecoach, and in a further twist Arriva (United's successor) acquired Stagecoach's operations, staff and depot in Darlington in a later deal.

Whatever the predictions of deregulation, few would have ever guessed that the operator providing nearly all bus services in Darlington would display the logo of the German State Railway, DB.

I hope you enjoy this photographic tribute to DTC and its staff. Against a level of hostile competition that I don't think any other established bus operator experienced, it survived longer than many in 1986 thought. For me, it was a time I look back on very fondly, and it was while driving a DTC bus that I met my lovely wife, Joanne.

My thanks to Mark Harrington for his photographic contribution and to Stephen Howarth, Geoff Gardner and other former employees for their input too.

I'm also grateful to the PSV Circle Fleetlist of DTC and Ian Wood's book *Darlington's Transport* for helping to jog my memory.

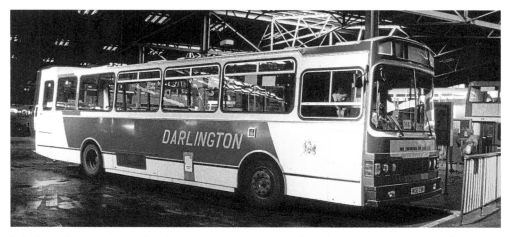

It is deregulation day, 26 October 1986, and it is DTC's first day trading. Being a Sunday, it was a rather quiet start with only four buses being needed: two buses for the tendered 268 service from Darlington to Stockton, and two for the 20, the town circular service. United operated all other Darlington town services. Ward Dalesman 2, ready to operate DTC's first journey, waits on the stand at Darlington bus station. The author is the driver on this historic day. Darlington's bus station was never the most photogenic location, being rather dark and smoky. It has since been demolished. Darlington Transport buses had never operated services from the bus station before. (M. Harrington)

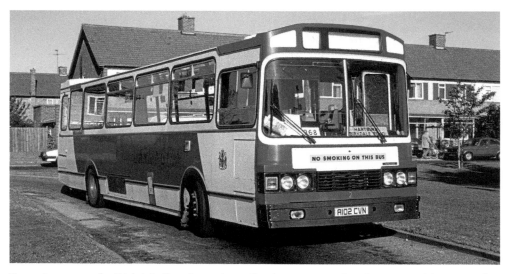

Bus 2 is seen at the Birkdale Road terminus, Stockton, on 26 October 1986. After arrival in Stockton, the bus operated a short trip on the 268 from Stockton High Street to Birkdale Road before returning to the High Street and then travelling back through to Darlington. Each full round trip took two hours, with two buses being required to run the timetable. The route number and destination were provided by boards until they were later added onto the blinds. The 268 was United's main route between Darlington and Teesside, traditionally operating as far as Redcar, although over the years there have been some extensions beyond Redcar. DTC's tendered Sunday version only covered the Darlington to Stockton section. In these days, before the relaxation of Sunday trading laws, loadings were very light. (J. Carter)

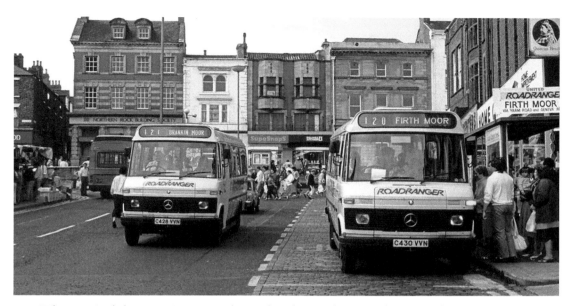

What awaited the new DTC; United introduced several waves of new minibuses to compete on Darlington town services. This was the first day of Roadrangers and illustrates the first two services. Competition in Darlington slightly predated deregulation day; on the same day, the new joint Dart service was launched by the Corporation and The Eden. There was also some short-lived competition from taxis that were now allowed to pick up at bus stops. 20 August 1986. (M. Harrington)

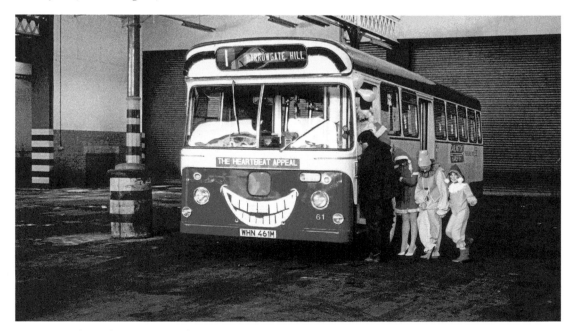

DTC's first Christmas saw the running of a charity bus. Seddon RU 61 is preparing to leave the depot, having been suitably decorated. Takings on the bus were donated to charity. The helpers comprised office staff along with the managing director's children. (J. Carter)

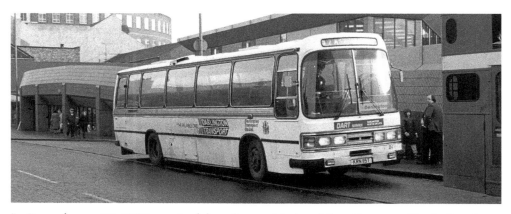

In December 1986, DTC acquired four former National Bus Company Duple Dominant coach-bodied Leyland Leopards. They were intended to upgrade the Dart service from its present bus Leyland Leopards and Ward Dalesmans, and they were also suitable for expanding operations into private hire work. The Dart service was an unusual joint service with independent operator The Eden, who were based at West Auckland. With deregulation looming, The Eden looked to expand their existing Bishop Auckland to Shildon service to Darlington via Newton Aycliffe. Darlington Transport were also looking towards Newton Aycliffe for their first competitive service and the first beyond the town boundary. The Eden operated half-hourly from Bishop Auckland to Darlington, while Darlington Transport operated in between on shorter workings to Newton Aycliffe, giving a joint fifteen-minute service between Darlington and Newton Aycliffe. One per-hour Darlington Transport service extended beyond Darlington east to Stockton and Middlesbrough. There were one or two variations; for example, certain peak time services by both Darlington and The Eden operated via the large trading estate in Newton Aycliffe, with one journey per hour turning into Aycliffe village rather than just passing by on the main A167 road. Darlington also operated one early morning journey through to Bishop Auckland. Bus 24, KRN 115T, is seen alongside Middlesbrough station, about to operate the 92A back through Darlington and on to Newton Aycliffe. 20 January 1987. (J. Carter)

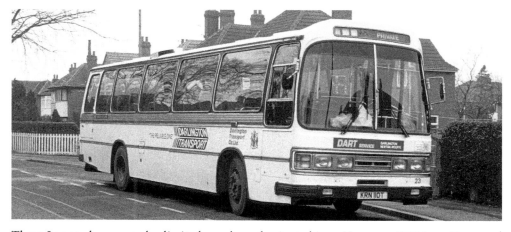

These Leopards operated a limited number of private hires. Here, 23, KRN 110T, paused at Clifton, York, on a wedding hire, for which it was used to transport guests from York to Darlington and back. The picture also shows the early fleet names, with Darlington Transport Company Limited spelled out in full along with Darlington Transport and the slogan 'The Reliable One'. The town crest was also still carried at this point. 21 March 1987. (J. Carter)

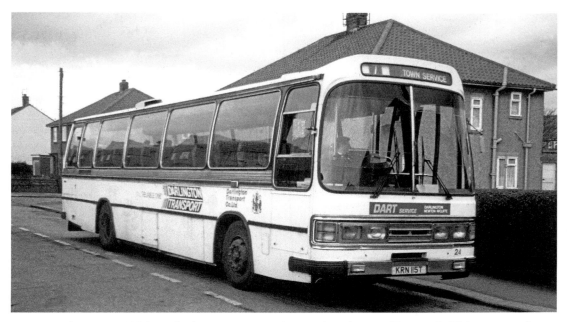

In early 1987, DTC launched a new competitive service, the 7 to Hurworth. This competed with United service 74 and was half-hourly. United's service was also half-hourly, although one per-hour service extended beyond Hurworth to Neasham. Unusually for a competitive bus service, the times were roughly evenly spaced with those of United. Hurworth is approximately 3 miles south of Darlington on the County Durham bank of the River Tees and is still within the Borough of Darlington. The service was marketed as 'The Silver Link', and this name was carried on the six Ward buses. Although the Wards were the most common buses in the earlier years, Leopard coach 24, KRN 115T, is seen here at the Hurworth terminus. 13 April 1987. (J. Carter)

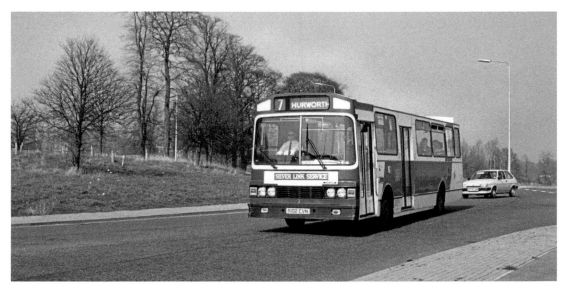

Ward Dalesman 2, A102 CVN, is seen at Blands Corner roundabout as it heads out of town towards Hurworth. 17 April 1987. (M. Harrington)

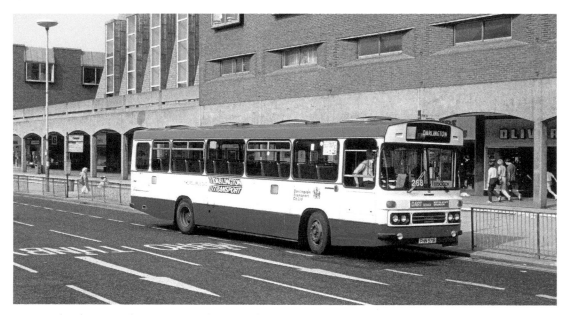

Leyland Leopard 71 is in Stockton High Street on the Sunday tendered 268 service. This small batch of four Leopards, PHN 569–72R, came into their own after deregulation with the expansion of services beyond the boundary of the town. Two of them, 70 and 72, had their centre doors removed as these proved draughty at higher speeds. 25 May 1987. (J. Carter collection)

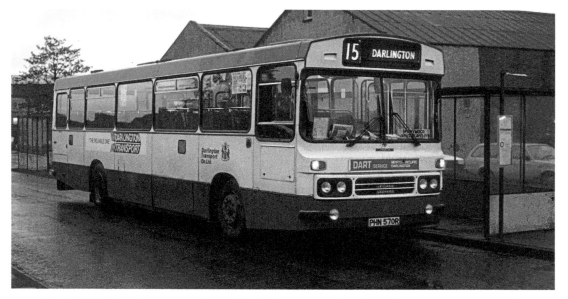

Another United service won under tender for three years after deregulation was service 15. This ran from Darlington through Newton Aycliffe and Chilton before terminating at Spennymoor. The tender was for the last two journeys only and so the first arrival into Spennymoor wasn't until about 20.50. Anything like a daylight picture was only possible in high summer; even in this image, taken in June 1987, lights are glowing. The terminus was just behind Spennymoor's main shopping street; although called a bus station, it was really a modest affair of four shelters.

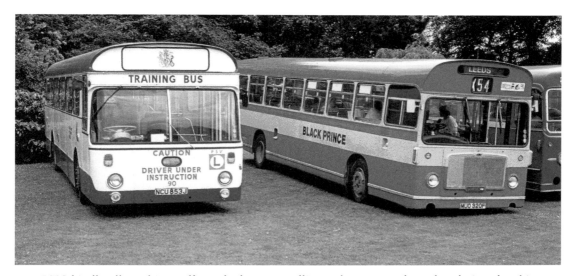

DTC kindly allowed its staff to take buses to rallies and events, and regular choices for this would be one of the two driving training vehicles or one of the Leopards, with 70 in particular being a popular choice. In this view, training bus 90, NCU 853J, was the bus of choice for a rally in Barnsley. It is parked next to a Bristol RELL-ECW, MUO 320F, which is operated by Leeds operator Black Prince. 90 was one of a batch of six Daimler Fleetlines with Marshall bodies that were acquired by Tyneside PTE in 1971. Five of the six were bought by Darlington Corporation in 1979 – four for service and this one as a driver trainer. The four service buses were withdrawn before DTC came into existence. 12 July 1987. (J. Carter)

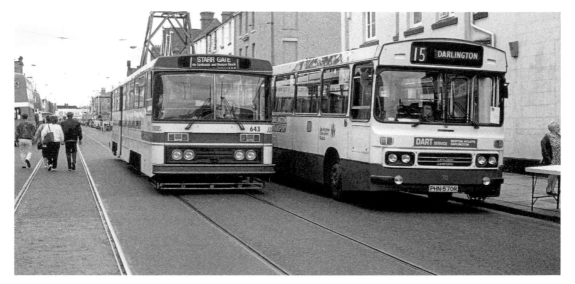

Another rally stalwart was 70, a Duple-bodied Leyland Leopard. In this scene it is parked at Fleetwood and is being passed by Blackpool tram 643. This was during the annual Tram Sunday event at Fleetwood. At this time participants on the rally were limited to staff and friends, with a 'whip-round' to cover the fuel costs. In later years, some events, such as this one, were advertised in the day trips brochure with drop off and pick up also being offered in Blackpool to widen the appeal and help fill the bus, or by then coach, up. 19 July 1987. (J. Carter)

Leyland Leopard coach 22, VRM 622S, is picking up in Stockton High Street on her way back
to Darlington and Newton Aycliffe on the hourly Dart service to and from Middlesbrough.
August 1987. (J. Carter collection)

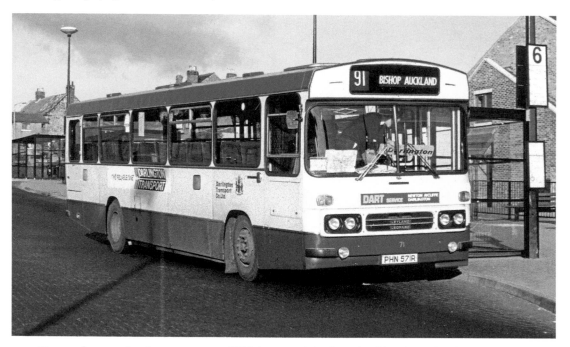

One early morning journey saw a DTC bus reach Bishop Auckland. Leyland Leopard 71,
PHN 571R, is seen after arrival at Bishop Auckland before returning towards Darlington.
September 1987. (J. Carter collection)

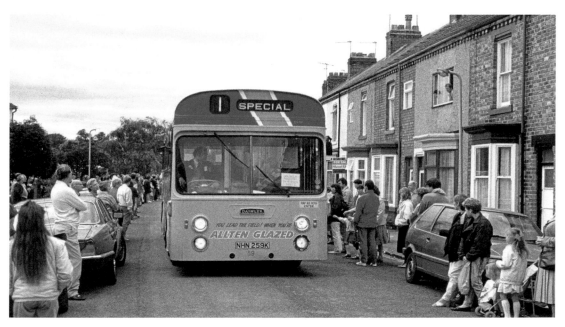

DTC's first overall advertisement livery was applied to Daimler Fleetline 59, NHN 259K. Unusually, it is seen here in Bedford Street, which is not normally a bus-served street, after attending the Railway Carnival in South Park. September 1987. (M. Harrington)

An unusual hire came from the United Enthusiasts Club, who hired 21, VRM 621S, for a tour of Cumberland Motor Services operations. 21 and 22 were both new to Cumberland and 21 is seen keeping company with a couple of Leyland Nationals at Workington. 21 November 1987. (J. Carter)

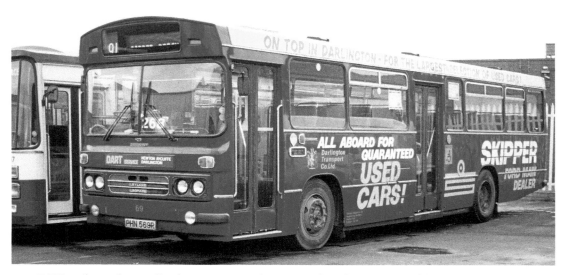

DTC embraced overall advertisement schemes on their buses. Several buses carried these colourful designs for local businesses. Leopard 69, PHN 569R, gained this blue-based scheme for Skipper's, the local Ford dealer, who had a large garage and showroom on the ring road, not too far from the DTC depot. Sadly, like DTC, Skippers's and their premises have disappeared from the town. 13 December 1987. (J. Carter)

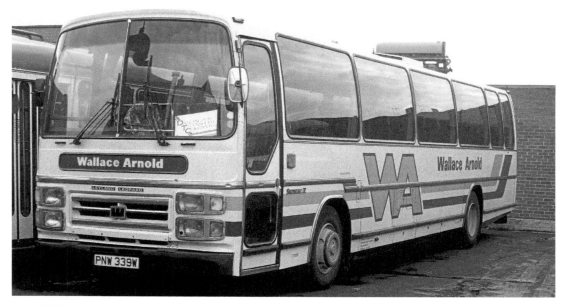

DTC's intention to develop a private hire and tour business saw the arrival of two 12-metre Plaxton-bodied Leyland Leopard coaches. These had been new to Wallace Arnold and arrived in their livery; thus, Wallace Arnold colours were adopted for the new venture. Not long after arrival, 39, PNW 339W, is seen at the depot still sporting Wallace Arnold names. These were nice vehicles to drive and travel on, and both remained with the company until the end. 13 December 1987. (J. Carter)

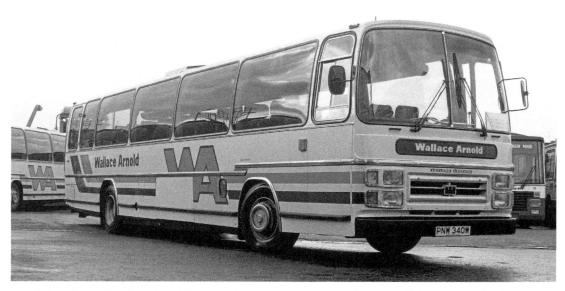

The other ex-Wallace Arnold Leopard, 40, PNW 340W, displays the offside view at the depot. 13 December 1987. (J. Carter)

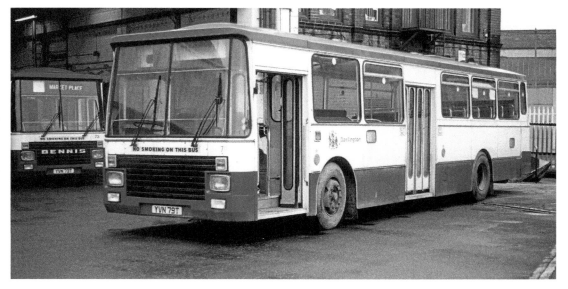

The Corporation had taken delivery of two batches of Marshall-bodied Dennis Dominators. The first ten, YVN 73–82T, received in 1979, were followed by a further eight in 1980, GHN 813–20V. Despite their relative youth, only two of the T-registered buses were taken into stock by DTC: 75 and 78. 79 was stored at the depot pending conversion to an exhibition vehicle for the council. The conversion never happened, and the vehicle was disposed of. Seen here, she had been moved out from her usual resting place along the back wall. In the background is the first Dominator, 73, which, although not initially part of the DTC fleet, was acquired from the council and put back into service. 73 was the only one to sport the large DENNIS across her front and had been displayed at the Commercial Motor Show when new. 13 December 1987. (J. Carter)

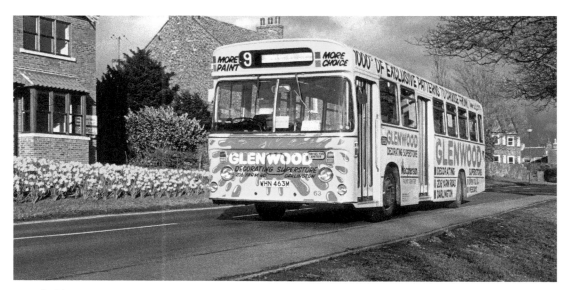

Seddon RU63, WHN 463M, was painted in this bright advertisement livery for a decorating store. 63 was always easy to spot among the other Seddons as its front end was rebuilt after an accident using an ex-Crosville Seddon as a donor. This left it with a cutaway front panel. The 9 was a peak-time competitive run from town to the nearby villages of Middleton St George and Middleton One Row. It gave members of the town fleet a chance to stretch their legs beyond the town boundary. The picture was taken at Middleton One Row in the company of some matching daffodils. 23 August 1988. (J. Carter)

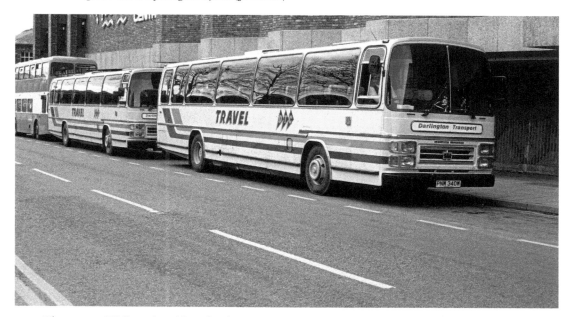

The two ex-Wallace Arnold Leyland Leopard coaches, 10 with 9 behind, are outside the town's Dolphin Leisure Centre on a private hire. By this time, they sported DTC Travel fleet names and the new logo of DTC within three triangles. A United Bristol VR is tucked in behind. 9 March 1988. (J. Carter)

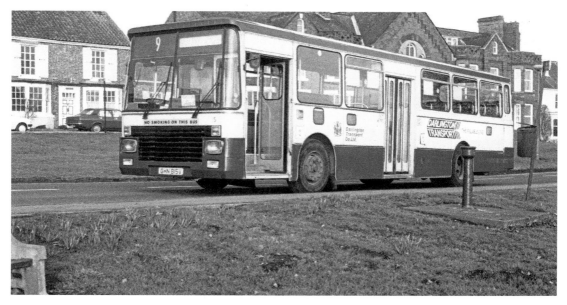

Dennis Dominator 15, GHN 815V, is seen at the village of Middleton One Row on short-lived service 9. 10 March 1988. (J. Carter)

The extension of the Dart service to Stockton and Middlesbrough had proved disappointing and it was discontinued; however, Wednesdays and Saturdays had been more popular, these being Stockton market days. A new X68 was introduced on Wednesdays and Saturdays between Darlington and Stockton and Middlesbrough. This was a shopper's service with two morning journeys from Darlington and two return afternoon ones. The service was popular, although traffic was mainly in one direction – discounted ticket prices for DTC concessionary pass holders proving popular over the more regular United service. Normally, the bus provided was a Leyland Leopard; however, on this occasion Stockton High Street got to witness the rare sight of a Seddon RU in the shape of bus 62, WHN 462M. 30 March 1988. (J. Carter)

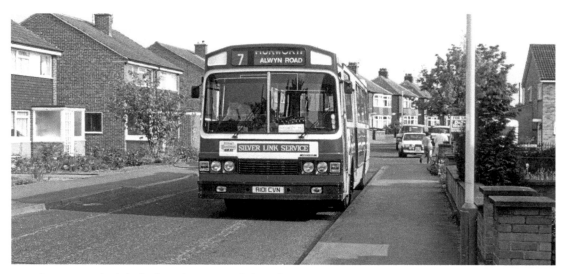

Service 7, which linked Darlington and the village of Hurworth to the south of the town, had been established. The other end was a bit more problematic and various parts of town were tried to give a successful cross-town route. One variation took the 7 to the north end of the town at Harrowgate Hill. Rather than to just turn around at the established terminus, the 7 was extended along Alwyn Round, which was not previously a bus route, and rejoined the main North Road at the White Horse pub. As it was popular at the time, the new section of route featured Hail and Ride rather than fixed bus stops. Ward Dalesman bus 1, A101 CVN, is in Alwyn Road in this view in May 1988. (J. Carter collection)

Ward Dalesman 1 is on the tendered 268 service. It is seen at Birkdale Road, Stockton, just before turning around between Stockton and Birkdale Road on the western edge of Stockton in May 1988. (J. Carter collection)

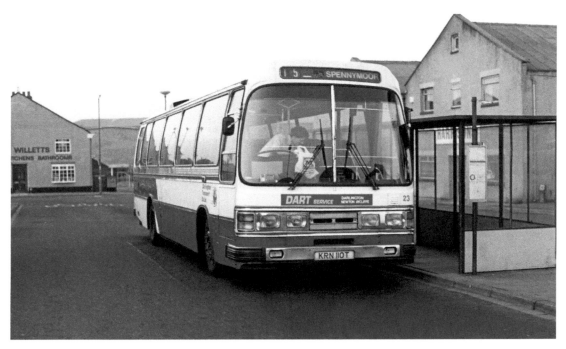

Another view of service 15 at Spennymoor with Leopard coach 23 in May 1988. (J. Carter collection)

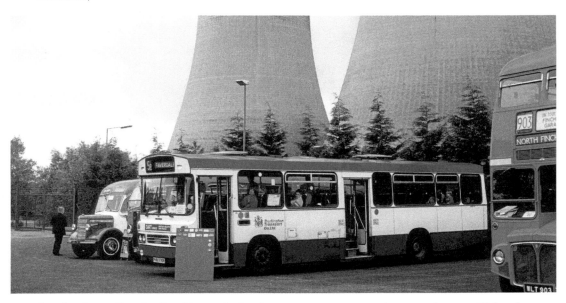

Another bus rally trip. On this particular day we went on a marathon run down to Didcot by way of Oxford. Leyland Leopard 70, PHN 570R, is seen under the cooling towers of Didcot Power Station. The weather wasn't the best and this picture, taken before the long return journey, features a few participants that were probably questioning their own sanity on this 400-plus-mile round-trip on a bus-seated Leopard. 5 June 1988. (J. Carter)

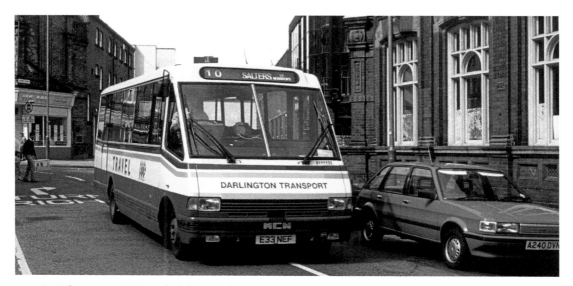

In July 1988, DTC took delivery of six new MCW Metroriders, 31 to 36, E31–6 NEF. The Salters circular services, 2B and 2C, had been badly affected by United's Roadrangers penetrating further into housing off Salters Lane South. The Metroriders were used to launch a new version of the DTC service, 10 and 11, which was able to run on some of the narrower roads too. Bus 33 is seen in Crown Street in the town centre. 17 July 1987. (M. Harrington)

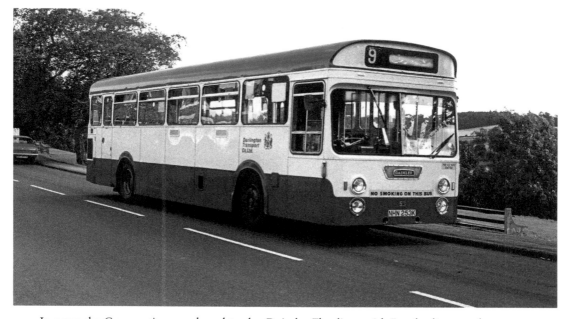

In 1972 the Corporation purchased twelve Daimler Fleetlines with Roe bodies, numbers 49 to 60, NHN 249–60K. Eleven of the twelve passed to DTC, with the unlucky other one, number 54, being withdrawn immediately prior to DTC commencing. The others enjoyed long lives and gave sterling service, with all eleven with DTC surviving into the 1990s, and some even surviving until the end of the company. Six of them even enjoyed operation after their DTC careers were over. Bus 53, NHN 253K, is seen at Middleton One Row. 22 August 1988. (J. Carter)

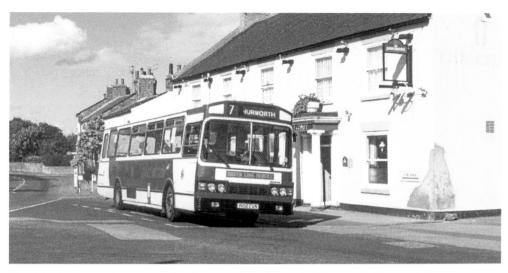

Ward Dalesman 2 is next to the Comet public house in Hurworth Place while en route to Hurworth. 4 September 1988. (J. Carter)

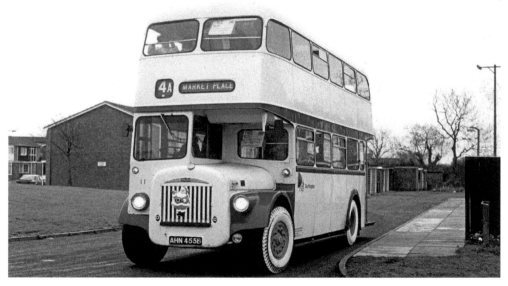

The Corporation's last double-deckers were a batch of twelve Daimler CCG5s with Roe bodies. The last were withdrawn from service in 1981. Bus 11, AHN 455B, was retained as a driver trainer and occasional towing vehicle. I passed my own PSV test on it in 1984. It passed to DTC, still as a driver trainer. In 1988 it had its destination screen reinstated and a few of the modifications from its driver training role removed. It ventured out in service as a free bus for special occasions; for example, in the run up to Christmas it performed over most of the town routes as a charity bus, with passengers being asked to make a charitable donation in lieu of their fare. A brief stop at Branksome terminus allowed a break from the driving seat and a picture. I had failed to notice the two youngsters on the upstairs front seat giving me two-fingered salutes, so a little bit of digital amputation to the picture has taken place. 17 December 1988. (J. Carter)

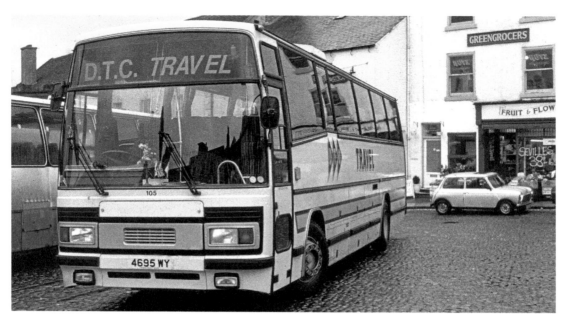

At the end of 1988, the DTC Travel coach fleet was upgraded and expanded with the arrival of three Volvo B10M coaches with Plaxton bodies. Like the two Leopard coaches, 9 and 10, they originated with Wallace Arnold. They had originally been registered FUA 382–4Y but when acquired carried cherished registration plates 1624, 3418 and 4695 WY, and were numbered 104, 108 and 105 in the DTC fleet. 105 is seen on the cobbles at Richmond. February 1989. (J. Carter collection)

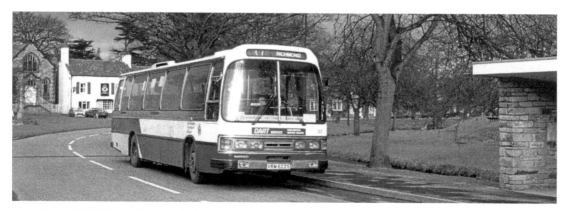

One of DTC's earliest tendering successes was services 37 and 38. These were two circular services from Richmond that served various villages in the Catterick area. The route required one bus, with the round trip taking fifty minutes, and the bus alternated between the 37 and 38 each time it arrived in Richmond. The service had been run by United from their Richmond depot. When DTC won the tender, United registered the daytime journeys commercially. DTC appointed four regular drivers to the service, and in the end DTC won the day and United withdrew their service. Passenger numbers were good enough that DTC ended up running the daytime journeys on a commercial basis, with only the evening runs subsidised. Leopard coach 22, VRM 622S, is pictured in Catterick Village, about halfway around the circle. 4 February 1989. (J. Carter)

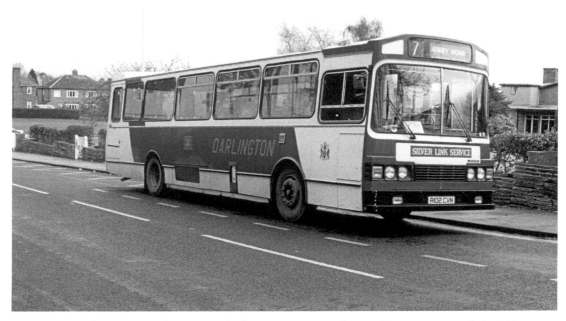

Another alternative to the town end of service 7 was tried, namely a route around the Abbey Road area of the west side of town. Ward Dalesman number 2 is seen outside Abbey Road School before returning via the town centre to Hurworth. 18 February 1989. (J. Carter)

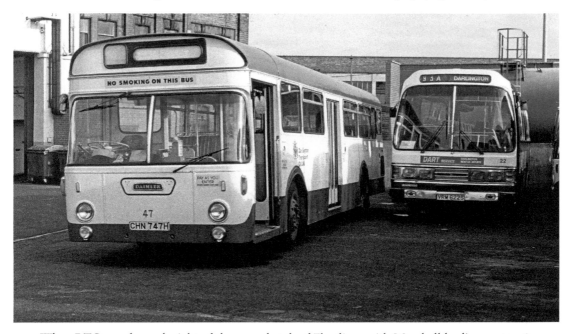

When DTC was formed, eight of the 1970 batch of Fleetlines with Marshall bodies, 37 to 48, CHN 737–48H, remained in service. These were withdrawn from service during 1988 and 1989, in part being replaced by a batch of new MCW Metroriders. Bus 47, CHN 747H, is at the depot in the company of Leopard coach 22. 19 February 1989. (J. Carter)

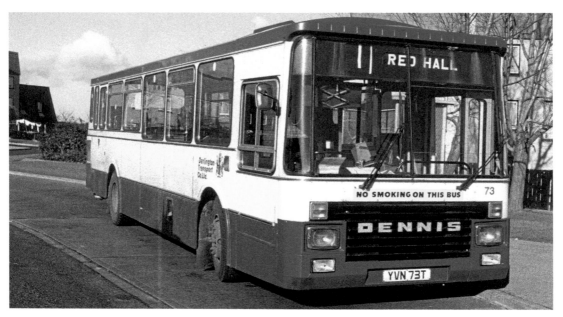

73, YVN 73T, a Dennis Dominator with Marshall bodywork, had not initially been transferred to the DTC fleet, remaining instead with the council. It was added to the DTC fleet in 1987 and served until 1989, being always recognisable by its DENNIS lettering across the front. It is seen at the Red Hall terminus of service 1 and 1A. This must have been around the time that the Autofare exact fare system was abandoned on town services as the cash hopper is still there but bagged over. 20 February 1989. (J. Carter)

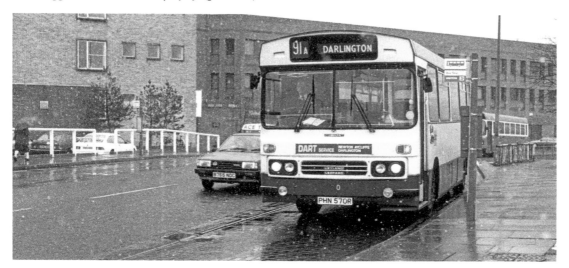

Leyland Leopard 70, PHN 570R, is seen waiting at Newton Aycliffe town centre on a wintery day with a United Leyland National about to pull in behind. DTC's part of the Dart service saw the buses follow a circular route around part of Newton Aycliffe before returning to the town centre and then heading back to Darlington. Service 91A went clockwise around the circle, while 92A, on the opposite half hour, went anticlockwise. The Eden's 91 and 92, after going halfway around the circle, headed off to Shildon and Bishop Auckland. 23 February 1989. (J. Carter)

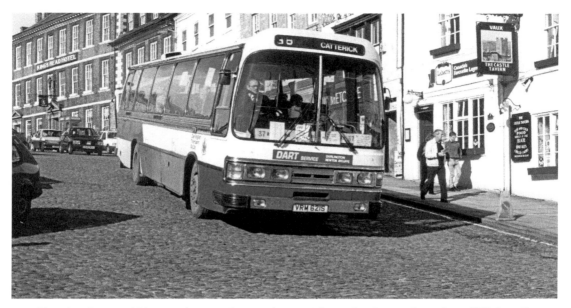

Two days later and it's a much more pleasant day in Richmond as Leopard coach 21, VRM 621S, rattles over the cobbles on its way out of town on a service 38. 25 February 1989. (J. Carter)

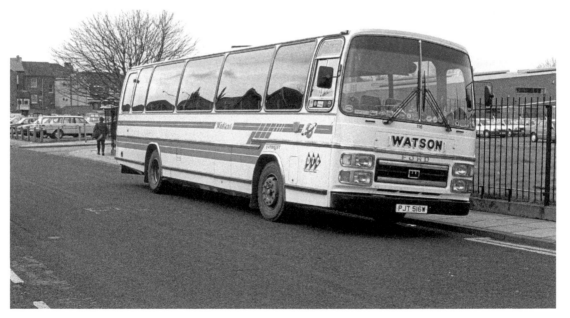

February 1989 saw the purchase of a local operator, Watson's of Hurworth. This brought four lightweight coaches to the DTC fleet, which was not typical for a former municipal operator. One of the vehicles, OUP 632M, DTC 112, a Duple-bodied Bedford YRQ, was disposed of more or less straight away; I certainly can't remember DTC operating it. The others served DTC for several years. The newest was this Plaxton-bodied Ford R1114, 116, PJT 516W, which is seen here in Park Place in Darlington. As was common with many independents at the time, it still sports a collection of stickers from previous trips. 16 March 1989. (J. Carter)

Daimler Fleetline 59, NHN 259K, is waiting time at the Harrowgate Hill, Longfield Road, terminus of service 8. Services 8 and 1 were linked at Harrowgate Hill. A service 1 bus that had travelled direct along North Road to Harrowgate Hill would turn into Longfield Road and become an 8. It would then return to town via the Rise Carr area before re-joining North Road and continue through town to Brankin Moor. After returning to Harrowgate Hill it would change back to a 1 to travel back through town via North Road and on to Red Hall. Many of the town services were linked this way and from a driver's point of view it helped with the tedium of town service. 24 March 1989. (J. Carter)

Just before withdrawal, Marshall-bodied Fleetline 47, CHN 747H, enjoyed a moment in the limelight when it very unusually worked a service 7 to Hurworth. In gathering gloom, it is about to pull into the bus stop at Blands Corner on the south-western edge of town. The petrol price sign bears witness to the ever-increasing cost of fuel. 29 March 1989. (J. Carter)

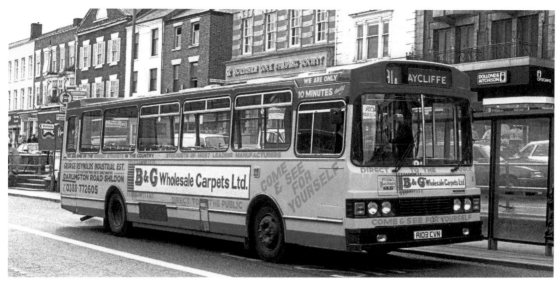

The only Ward Dalesman to gain an overall advertisement was bus 3, which is seen here on a Dart service 91A to Newton Aycliffe on what looks a quiet day. 3 May 1989. (M. Harrington)

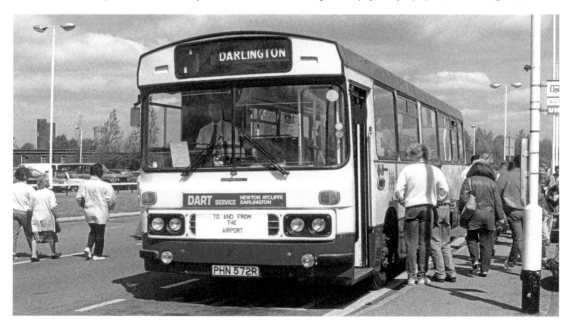

The local airport, Teesside Airport, hosted an annual air show. Here, Leopard 72, PHN 572R, is seen outside the terminal building on an air show special service. By this time two of the Leopard buses, 70 and 72, had been rebuilt to single-door layout. As the Leopards spent most of their time on out-of-town routes, their dual-door layout had proved rather draughty on the open road. The decline of the airport, now called Durham Tees Valley, is highlighted by the fact that no bus services go there at all now. Its total public transport provision is now one train per week (on a Sunday) in each direction. On a slightly more positive note, the air shows have returned after a gap of several years. 14 May 1989. (J. Carter)

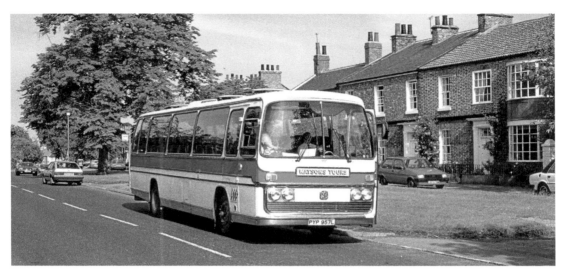

Former Watson's Bedford YRT 117, PYP 957L, is seen in the village of Hurworth. 19 June 1989. (M. Harrington)

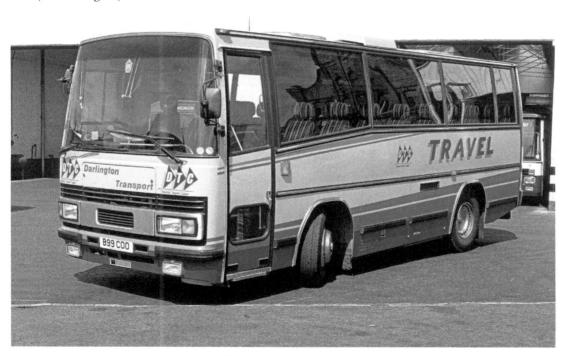

Another 1989 acquisition was this Plaxton-bodied Ford R1115, B99 COO, which is usually referred to as 'Cooey'. Like many of the coaches for the DTC Travel fleet it retained its previous operator's colours – in this case Hornsby of Ashby near Scunthorpe, but with the addition of DTC names and logos, although it did receive the Wallace Arnold-style livery towards the end of DTC. It was originally a demonstrator for Ford, hence the Essex registration, with the chassis being shortened before bodying. It proved a useful member of the coach fleet and served until the demise of the company. It was exported after sale, probably to Ireland. 25 June 1989. (J. Carter)

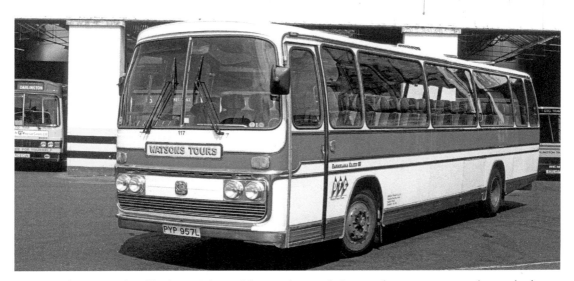

Another view of Bedford 117. These older coaches tended to work on contract work. 117 had a typical Bedford 'rice pudding' gearbox, but it was a nice, warm coach in the winter months. 25 June 1989. (J. Carter)

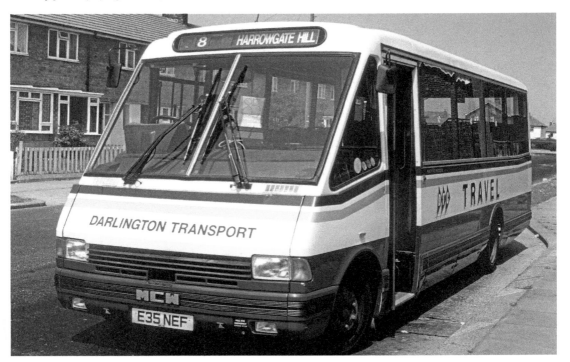

This MCW Metrorider is at Brankin Moor terminus on a service 8. A short-lived feature of these buses was music being played from the vehicle's radio cassette system. As the vehicles were noisy at the front, drivers tended to have the volume turned up so they could hear it, and this deafened the passengers. The music systems were quickly removed. 6 July 1989. (J. Carter)

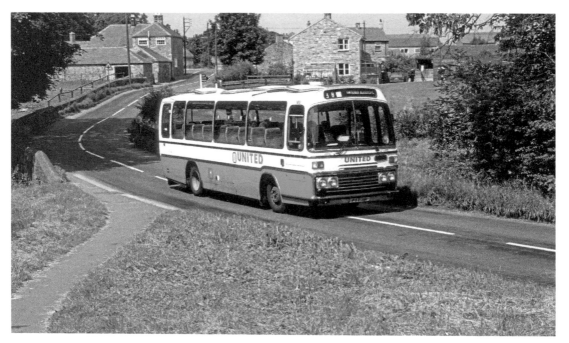

Typical of the competition DTC faced was this United Plaxton-bodied Bristol LH, PTT 71R, which is seen running just in front of the DTC service at Scotton near Catterick Garrison. 14 July 1989. (J. Carter)

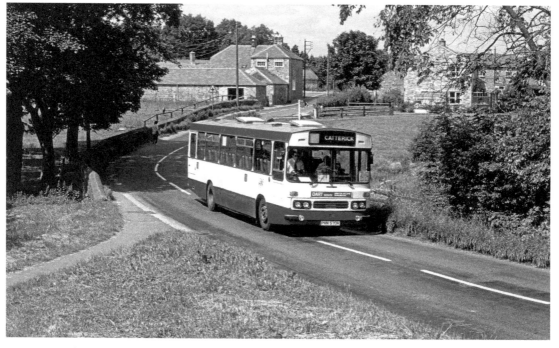

Leopard 70, PHN 570R, passes the same spot five minutes later. 14 July 1989. (J. Carter)

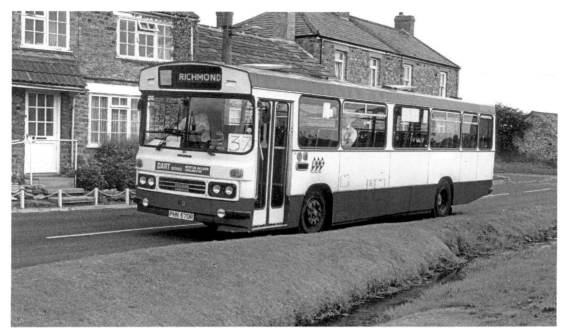

Leopard 70 is seen on service 37 at the village of Tunstall. 14 July 1989. (J. Carter)

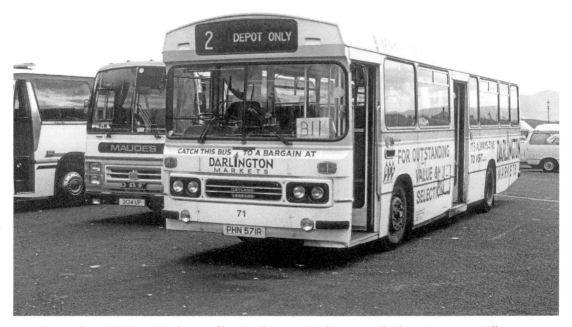

Leopard 71, PHN 571R, shows off its Darlington Markets overall advertisement at Killington Lake Services on the M6. Buses 71 and 69 retained their dual-door layout, which was an unusual feature for these Duple Dominant bus bodies to have. The Tram Sunday event at Fleetwood was this day's destination. 16 July 1989. (J. Carter)

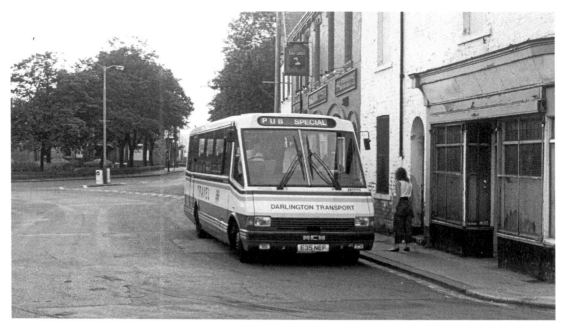

Two Metroriders received turbochargers to make them more suitable as private hire vehicles. 35, E35 NEF, had been hired by the Darlington branch of the Campaign for Real Ale (CAMRA) for a tour of pubs in Hartlepool. The picture was taken in Hartlepool and 35 sports an appropriate destination display. 19 July 1989. (M. Harrington)

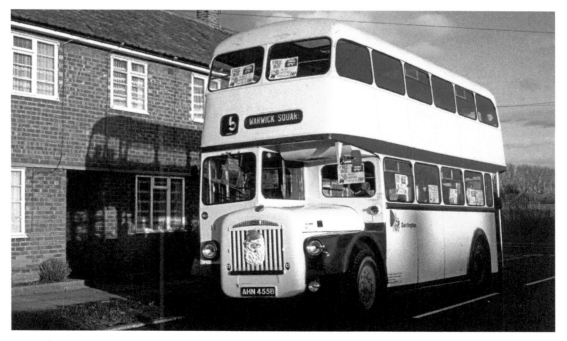

Christmas 1989 saw bus 11 doing another day of charity specials around the town. Warwick Square is the location here. 23 December 1989. (J. Carter)

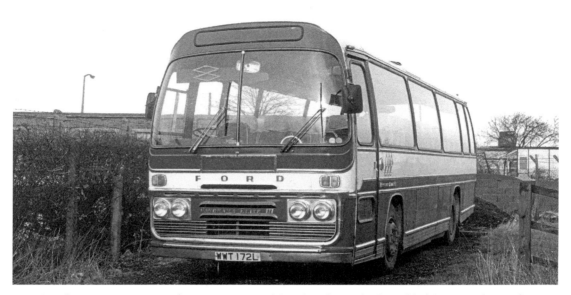

Another operator acquired in 1989 was Rydal's of Richmond. This added four coaches and a minibus to the DTC fleet. The Rydal business also included taxis around Richmond. Former Rydal coach 122, WWT 172L, a Plaxton-bodied Ford R1014, is at the former Rydal depot on Gallowfields Industrial Estate in Richmond. 122 was later transferred to the main depot in Darlington, with the old coach seats having been replaced with bus seats from a withdrawn Fleetline. It then became the regular vehicle on the Barnard Castle School contract, and also undertook some driver training work. 27 January 1990. (J. Carter)

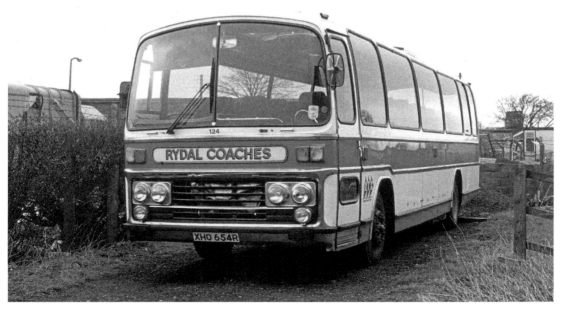

Richmond depot is also the setting for XHO 654R, a Bedford YMT with Plaxton bodywork that was numbered 124 in the DTC fleet. 10 February 1990. (J. Carter)

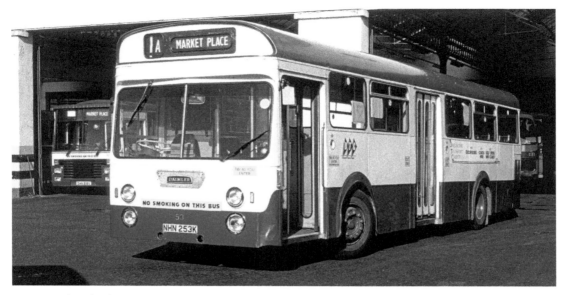

Daimler Fleetline 53, NHN 253K, is at the depot in this picture. This batch of Fleetlines served Darlington particularly well. 53 was withdrawn a month after this picture was taken, having notched up eighteen years' service. Some buses managed twenty-two years, lasting until the end of DTC, and a few of those served after DTC with independent operators. 11 February 1990. (J. Carter)

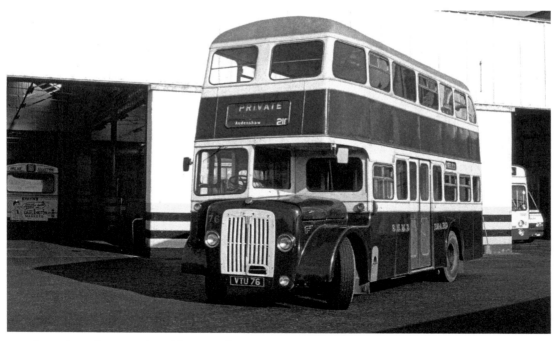

Sometimes there was the odd surprise bus enjoying some DTC hospitality at the depot. VTU 76 is a preserved Daimler CVG6 with Northern Counties bodywork; it had been new to Stalybridge, Hyde, Mossley & Dukinfield in 1956. 11 February 1990. (J. Carter)

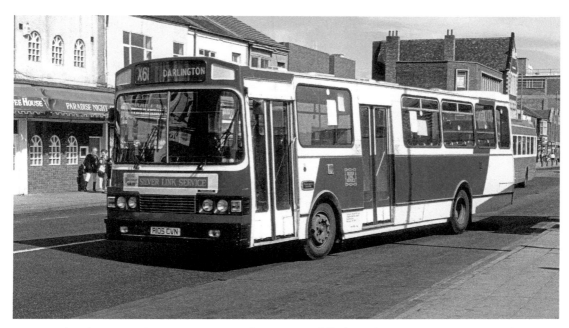

Ward Dalesman 5, A105 CVN, is seen departing Middlesbrough on an X68 service. As there are no passengers on board this probably means this was the morning, and bus 5 had already dropped its passengers off for a few hours of shopping. 16 April 1990. (J. Carter)

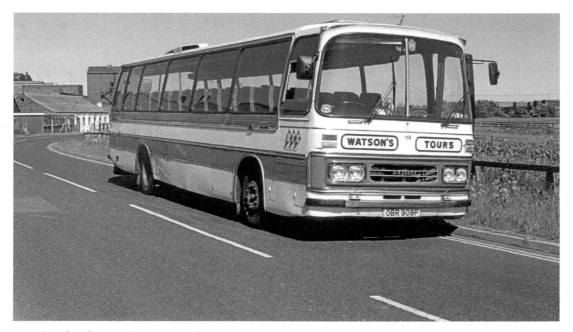

Another former Watson's coach, OBR 908P, a Ford R1114 with Duple bodywork, is numbered 118 in the DTC fleet. After completing a school contract from Hurworth School, 118 is at Urlay Nook, where it is ready to return empty to the depot. In the background is the now demolished chromium works. 25 April 1990.

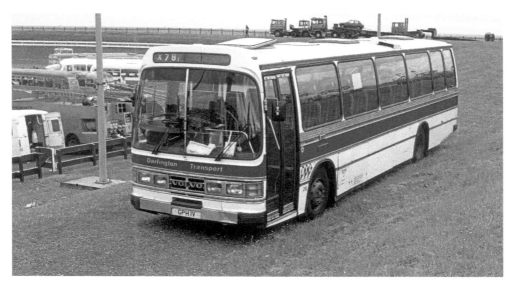

Acquired in 1990 was this Volvo B58 with Duple bodywork. GPH 1V was new to London Country and was used on Green Line express services in the London area. Numbered 26 in the DTC fleet, Green Line livery has been quickly altered for DTC use by painting the green band blue. DTC used it mainly for the X78 service to the Garden Festival at Gateshead that was taking place that summer. In this view she is on rally duty, and had taken part in the annual Tyne Tees Run, which finishes at South Shields, where the picture has been taken. 3 June 1990. (J. Carter)

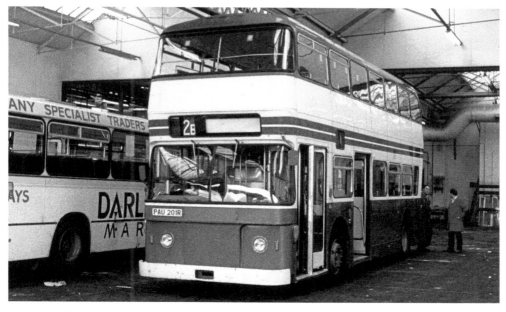

In 1990 DTC acquired five double-deck Daimler Fleetlines with Northern Counties bodywork from Nottingham City Transport. They had been well maintained and drove well, although the Nottingham style bodies were, perhaps, an acquired taste. Some did see brief use in Nottingham green and cream. Here, bus 201, PAU 201R, is being prepared for service at the depot. 7 June 1990. (M. Harrington)

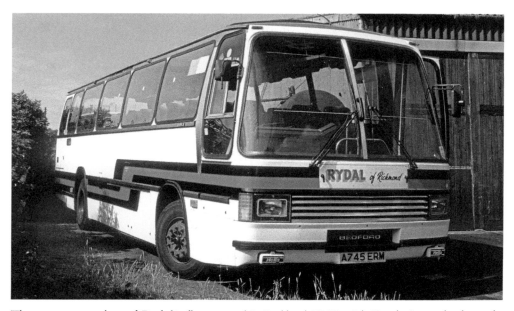

The newest member of Rydal's fleet was this Bedford YNT with Duple Laser bodywork. Numbered 125 in the DTC fleet, from this angle, at Richmond depot, there is no sign of DTC ownership. 1 July 1990. (J. Carter)

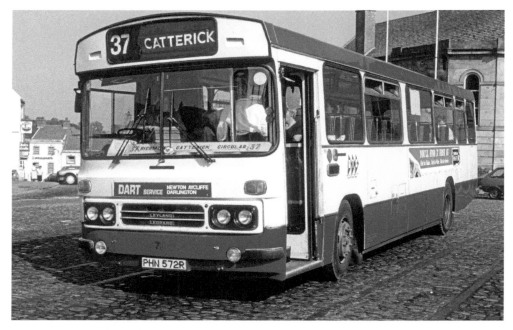

On any trip to Richmond I found it hard to resist another picture of the DTC bus on the 37 and 38 circular. On a fine day, Leopard 72, PHN 572R, is the allocated bus. It was a different pace of life on this service; some of the regular old ladies would drop shopping off onto the bus, whereupon the shopping would enjoy an hour or two's ride around before being reunited with its owner for the trip home. 1 July 1990. (J. Carter)

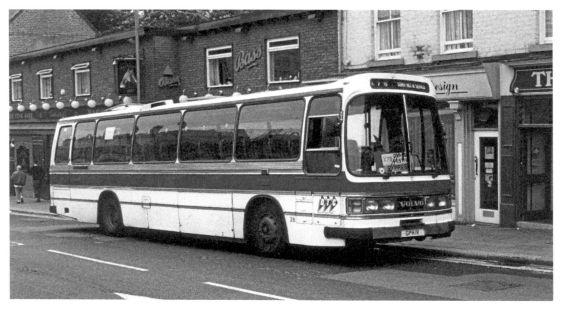

Volvo B58 coach 26 is seen laying over between X78 runs to the Gateshead Garden Festival. Loadings proved disappointing and it was amalgamated into the express service to the Metro Centre, which had begun the previous year. The picture was taken in Tubwell Row in Darlington town centre. 21 July 1990. (M. Harrington)

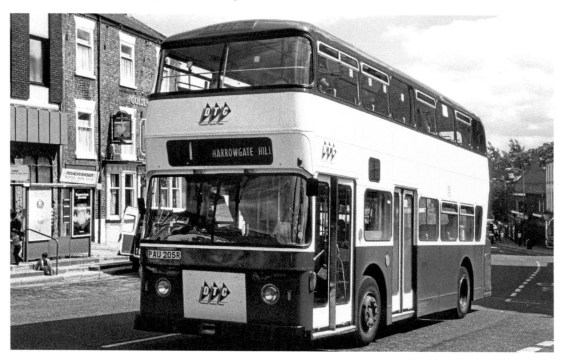

Ex-Nottingham Fleetline 205, PAU 205R, which is seen here at Tubwell Row, operated for a while with this cream panel between the headlights. 7 August 1990. (M. Harrington)

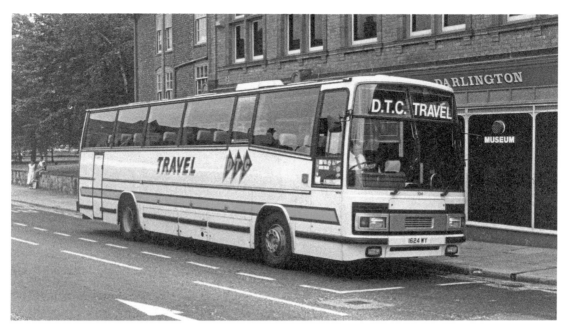

Also parked in Tubwell Row is Volvo B10M coach 104, 1624 WY. In the capable hands of coaching manager Geoff Gardner, DTC Travel operations quickly became well established, with day trips, holidays and general private hires keeping the fleet and its dedicated drivers busy. 21 September 1990. (M. Harrington)

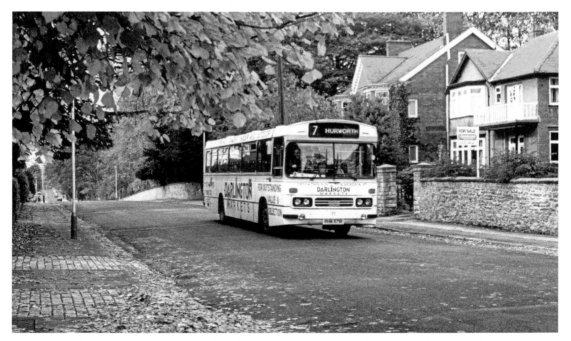

Leopard 71, PHN 571R, is seen heading into town along Milbank Road. 31 October 1990. (M. Harrington)

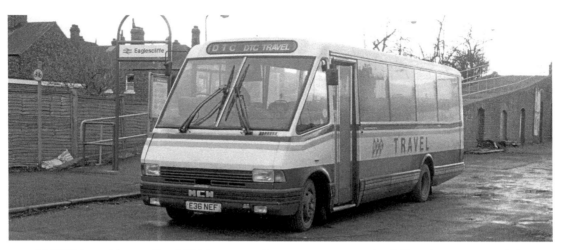

MCW Metrorider 36, E36 NEF, is waiting for passengers at Eaglescliffe railway station while on hire to British Rail. 36 was used to cover the intermediate stations between Darlington and Eaglecliffe of Dinsdale and Allens West – a full-size coach ran directly from Darlington to Eaglescliffe and back while train services were interrupted for engineering work. 20 January 1991. (J. Carter)

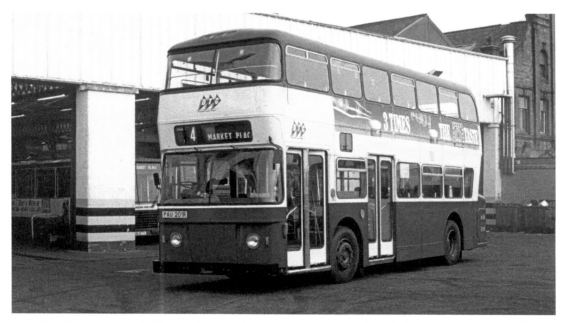

Fleetline 201, now in blue and cream, is seen at the depot. Although this bus' capacity would rarely be needed in these days of intense competition between DTC and United, the Fleetline was a well-known and popular bus at the depot. Although all of Darlington's Fleetlines had been single-deck versions, the relatively poor-selling single-deckers had been dropped by Daimler in the early 1970s, so if DTC wanted to obtain any newer examples the double-decker version was the only one available. Prior to these buses arriving, Darlington had not owned any rear-engine double-deckers, and the last ones had been the half-cab, rear-loading CCG5s of 1964. 3 February 1991. (J. Carter)

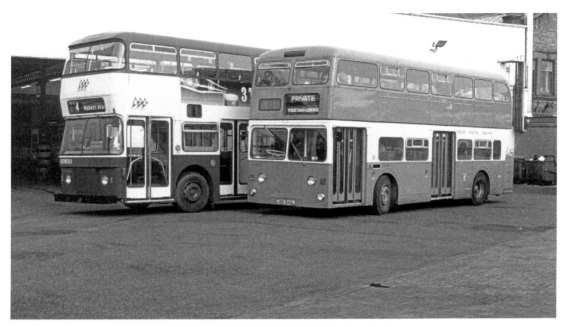

201 is now seen posed next to the preserved Northern Counties-bodied Daimler Fleetline JDC 544L, owned by the Teesside-based 500 Group. Despite both being bodied by Northern Counties, the styling is very different, and so is the height; while 201 is a full height vehicle of 14 feet 6 inches, 544 only has a height of 13 feet 5 inches. 3 February 1991. (J. Carter)

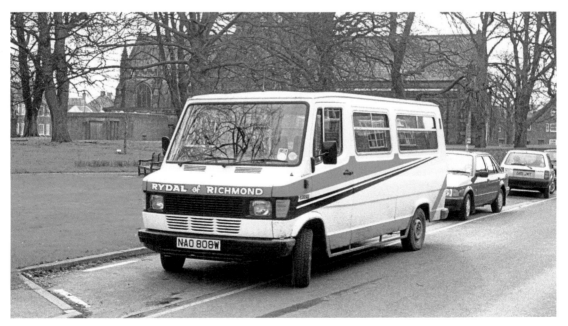

The smallest member of the former Rydal fleet was this twelve-seat Mercedes minibus with Reeve Burgess bodywork. NAO 808W became DTC 128 and is seen here in Northallerton. 15 February 1991. (M. Harrington)

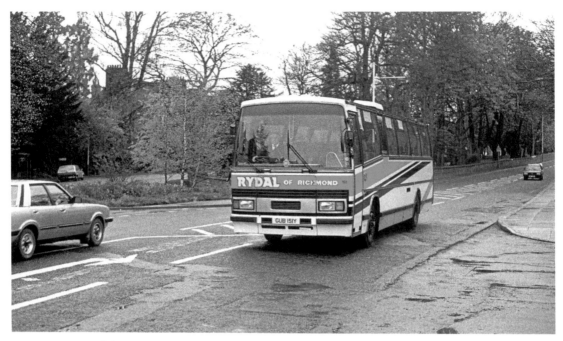

Former Rydal GUB 151Y, DTC 121, a Bedford YNT with Plaxton bodywork, is passing along Grange Road in Darlington, no doubt returning to Richmond. 18 February 1991. (M. Harrington)

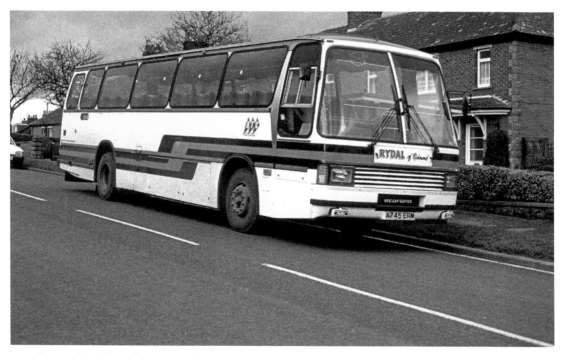

Former Rydal coach 125 now has DTC logos added to its livery. 19 February 1991. (J. Carter)

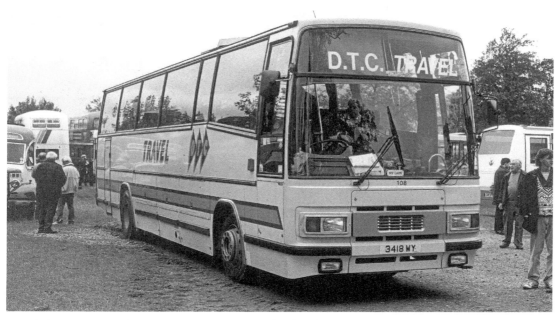

Volvo B10M coach 108, 3418 WY, is seen at the Showbus event at Woburn Abbey. This annual event is the biggest bus and coach rally and features vehicles from the latest, newest designs back to the earliest. The grounds at Woburn were notoriously boggy, and 108, like many others that day, needed a helping hand from a tractor to escape the mudbath. 29 September 1991. (J. Carter)

MCW Metrorider 33, E33 NEF, is posed at the depot. 12 January 1992. (J. Carter)

Dennis Dominator 17, GHN 817V, is also at the depot. The eight V-registered Dominators, 13–20, fared much better than the ten T-registered versions. Only three of the earlier batch saw service with DTC, while the later batch remained in service until April 1993, although none quite managed to last until the end of the company. Their Marshall Camair bodies were quite stylish, and the Dominators had the first fully automatic transmissions in the Darlington fleet. They were a bit of a 'Marmite' bus with the drivers – some loved them, some hated them. 12 January 1992. (J. Carter)

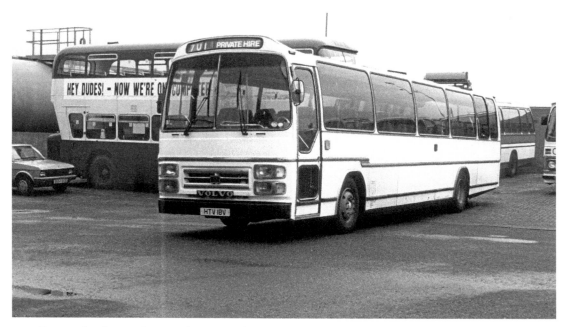

Seen at the depot when newly acquired is a further Volvo B58, this time with a Plaxton body. This coach, HTV 18V, new to Skill's of Nottingham, received the fleet number 28. 19 January 1992. (J. Carter)

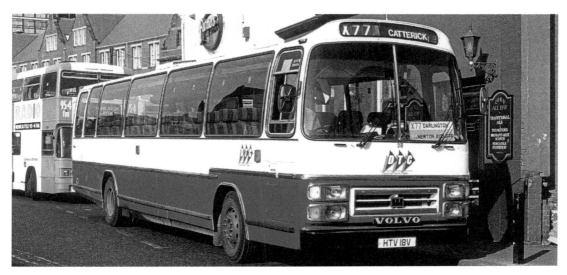

The following month, 28, now with a blue skirt, was parked at Newcastle before working an X77 journey right through to Catterick. This service had started out as a regular day trip from the DTC Travel unit to the Metro Centre from Darlington before being developed into a six-days-a-week service. Some journeys also operated via Chilton and Ferryhill. This service was very popular, and duplication was often required. On Saturdays, a through journey was offered from the Richmond and Catterick area by extending one of the 38 runs from Richmond right through to Newcastle. A corresponding opposite journey was put on in the evening, allowing some of DTC's North Yorkshire customers a day trip. Another bus would slot in to cover the 37 and 38 service. 29 February 1992. (J. Carter)

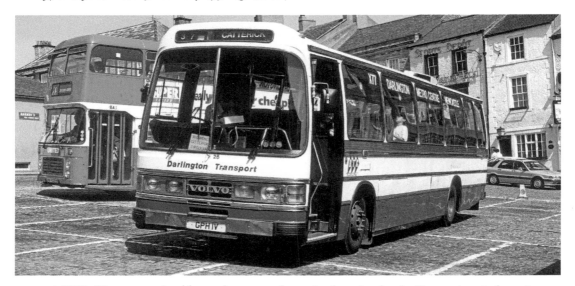

26, GPH 1V, now sporting blue and cream and carrying lettering for the X77 on its windows, is on the 37 and 38 service at Richmond. Buses are using temporary stops at the lower end of the marketplace in this scene. United Bristol VR 841 has arrived from Darlington and it too would be heading towards Catterick Garrison, although not on a directly competing service with DTC. 26 February 1992. (J. Carter).

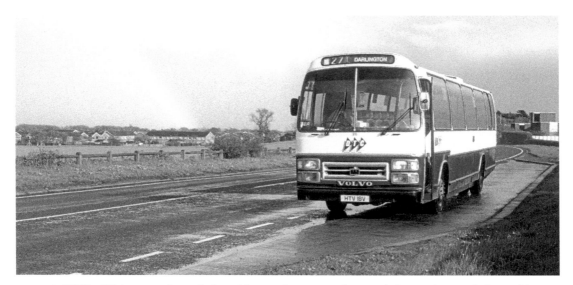

28, HTV 18V, has run through from Newcastle, operated around the service 37 circle, and is now running back to Darlington as a 27 service. By now, all the passengers are off, and it would be a more or less empty run back to Darlington and the depot. There was just time for a quick, posed shot, with the aid of a rainbow, next to Catterick Racecourse (out of the picture on the right). 2 May 1992. (J. Carter)

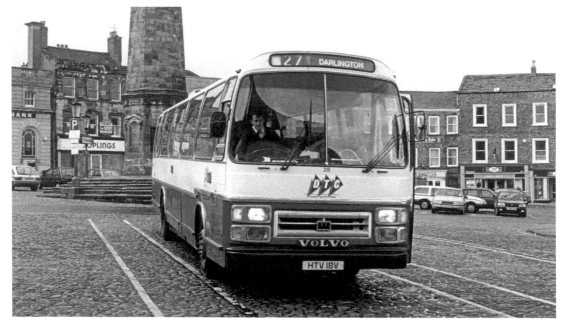

28, HTV 18V, is now at Richmond marketplace as it heads back to Darlington. At this time, DTC did not compete directly with the United 'mainline' 27 and 28 service, but odd journeys did run as a 27 as a cost-effective way of getting buses between Richmond and Darlington for both 37 and 38s and, as in this case, the Saturday X77. A younger version of the author is the driver. 2 May 1992. (J. Carter collection)

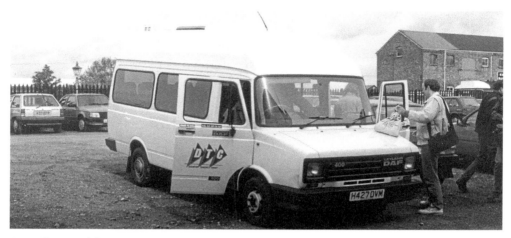

A small part of the DTC operation was hiring out a self-drive minibus. Initially, a Ford Transit, D998 EAJ, number 98, was operated. This was later stolen and was replaced by another Transit, number 25, F725 MNB. The Transit was augmented by this later addition, H427 DVM, number 27, a DAF 400 with Made 2 Measure bodywork. This was a rather better-appointed vehicle than the Transits. A colleague (pictured with the DTC carrier bag) and I hired it for a trip to the Severn Valley Railway, taking with us a group of friends. The picture was taken at Kidderminster after arrival, and a good day was had by all. On the return journey we had slightly underestimated how much fuel was left and we had to push it for about the last 50 yards to the depot gates. 10 May 1992. (J. Carter)

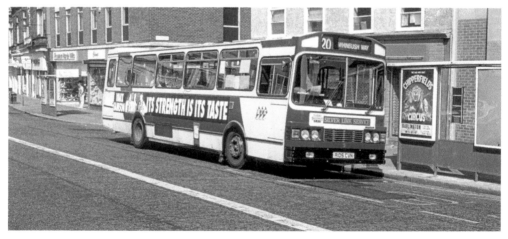

As mentioned at the start, DTC did not fare well in retaining Sunday town services, which were put out to tender and won by United. DTC operated, on a commercial basis, a circular service, number 20. This operated clockwise from the town centre via North Road to Harrowgate Hill, then along Salters Lane North, around Whinbush Way and returning via Haughton Road to town. Strangely, both directions were numbered 20, whereas other circular services differentiated between the two directions; i.e., 2B and 2C, 10 and 11. It has to be remembered that Sunday trading laws weren't relaxed until August 1994, so, for nearly all of DTC's existence Sunday services were very quiet, with a busy period around pub and club trading hours before they too were relaxed. Ward Dalesman 5, A105 CVN, is seen on a 20 service at the Prebend Row stop, in the town centre. 17 May 1992. (J. Carter)

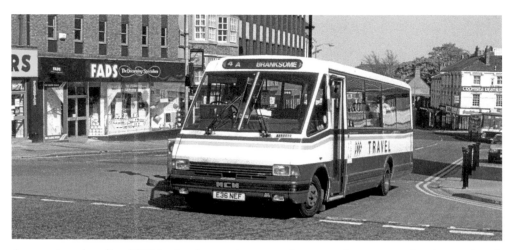

As mentioned earlier, DTC had only run the 20 service around town on a Sunday, and each year there was a battle to sell pensioners annual passes. After deregulation, Darlington Borough Council issued eligible pensioners and disabled passengers a fixed amount of transport tokens. For regular travellers this would never be enough to last all year. DTC had stolen a march on United by offering an annual pass in return for the annual supply of tokens, and pass holders then paid 5p per journey. United quickly responded with their own version, and so each April there was the annual 'grab a granny' battle between the companies at the town hall when tokens were issued. Many passengers used weekly or monthly season tickets, with both DTC and United offering their own versions. One drawback for DTC was the lack of Sunday services, so some were reintroduced on the busier routes. Here, MCW Metrorider 36, E36 NEF, is at the top of Tubwell Row on a Sunday 4A to Branksome. 17 May 1992. (J. Carter)

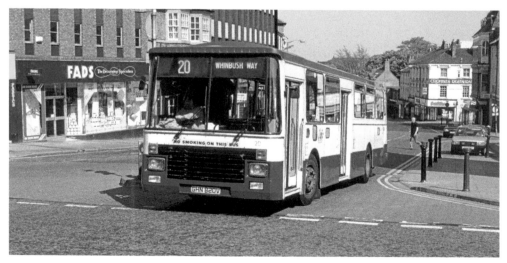

The Sunday-only 20 service still continued to operate. Dennis Dominator 20, GHN 820V, is at the top of Tubwell Row. This location, looking down from the steps leading up to Tubwell Row, was always a popular spot for bus photographs over the years. However, the remodelling of the town centre and changes to traffic flow have meant that this particular shot is no longer possible. The quietness of the town centre can be seen in the years before Sunday trading laws were relaxed. 17 May 1992. (J. Carter)

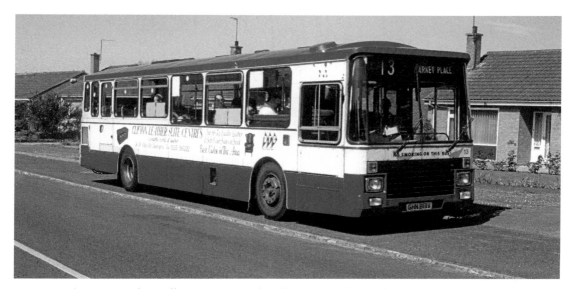

For a few years, a bus rally was organised in the town, and DTC kindly allowed staff to enter buses each year. Dennis Dominator 13, GHN 813V, is seen in Neasham village on the banks of the River Tees while undertaking a run around the area from the rally site. DTC served this village on tendered evening runs for a while, but it was usually United who provided the service here, and on an hourly basis. Like many of Darlington's surrounding villages, funding cuts to bus services have meant that this village now has just a Monday service, and even that is under threat. 17 May 1992. (J. Carter)

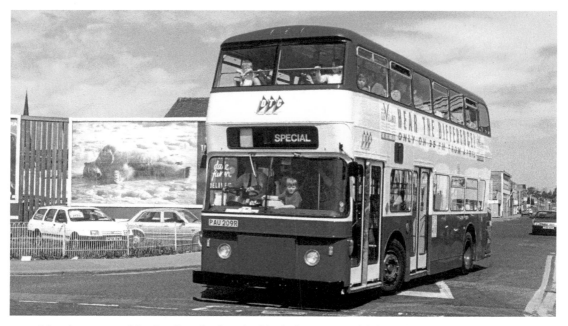

After the success of the first five Fleetline double-deckers, DTC added another two. 209, PAU 209R, had joined the fleet at the beginning of 1992 and is seen emerging from Valley Street while giving a healthy load of passengers a tour during the town bus rally. 17 May 1992. (J. Carter)

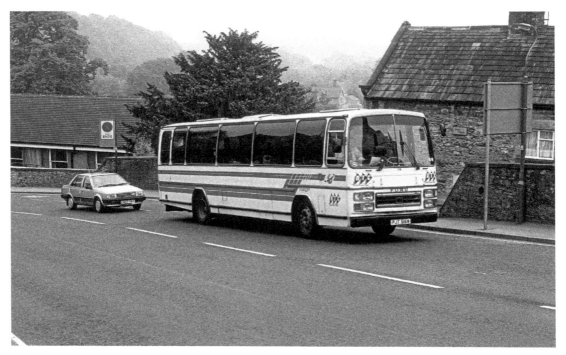

An ex-Watson's Ford R1114, 116, PJT 516W, is seen climbing up towards Richmond on a school contract. 8 June 1992. (J. Carter)

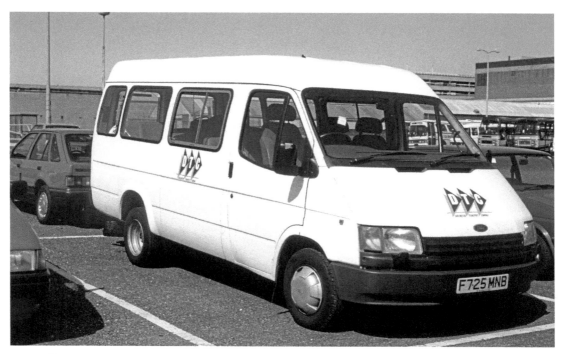

Self-drive hire Ford Transit minibus F725 MNB is parked in Blackpool. 19 July 1992. (J. Carter)

Another DTC bus in Blackpool on the same day was Volvo B58 28, HTV 18V. By this time, the annual trip to Tram Sunday at Fleetwood was advertised in the day trips programme, with a pick-up and set-down in Blackpool also being offered. 19 July 1992. (J. Carter)

The popularity of the former Green Line Volvo B58 26, GPH 1V, encouraged DTC to acquire its twin GPH 2V, which was fleet number 29. These two Volvos had been used for comparison purposes in London against the more usual Leyland Leopard and AEC Reliance coaches. They happily sat at the then maximum speed of 70 mph on the motorways, whereas the Leopard coaches could be reduced to about 40 mph on some of the hills. 29 is seen at the Gateshead Metro Centre before returning south again on the X77. 28 January 1993. (J. Carter)

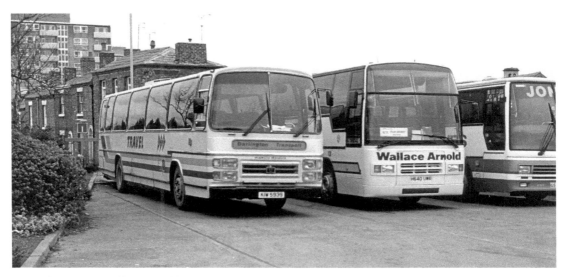

The two ex-Wallace Arnold Leopards were refurbished inside, fitted with DAF engines and were registered KIW 5939 (9), and KIW 5940 (10). 9 is seen here in Chester, parked next to a member of the Wallace Arnold fleet. 6 February 1993. (J. Carter)

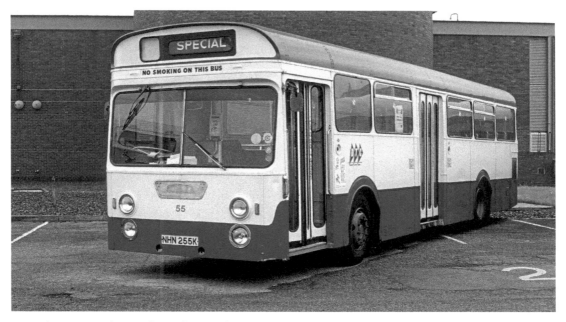

The 1993 Darlington bus rally saw Fleetline 55, NHN 255K, being exhibited. Most of this batch were still in service and were then twenty-one years old. DTC had invested in new Wayfarer 2 ticket machines coupled with a card reader for season tickets. The cards used for the season tickets had magnetic strips that were read by the machine visible on the bulkhead, just behind the driver. Although cutting edge at the time, the readers proved unreliable, and the more low-tech solution of the driver examining the card became the norm. The bus is seen at the car park of Cummins, a major employer in Darlington, who had kindly allowed its use for the rally. 16 May 1993. (J. Carter)

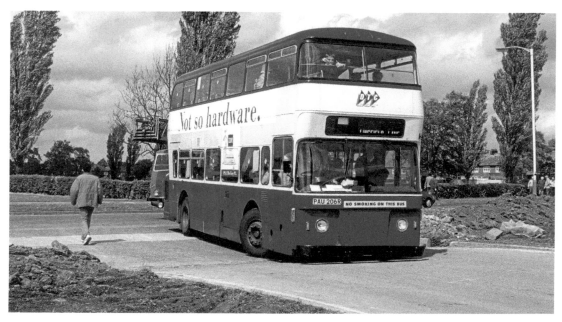

Fleetline 206, PAU 206R, is proving popular for rides as it turns back into the Cummins site during the rally. 16 May 1993. (J. Carter)

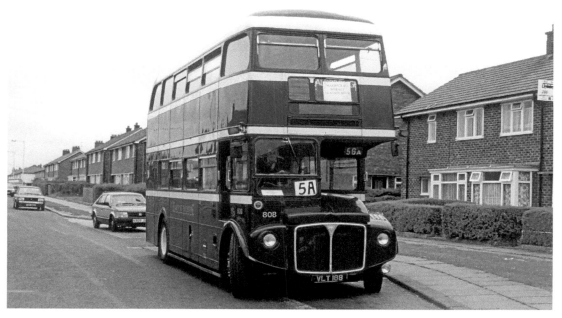

In 1993 DTC launched a bold trial of reintroducing conductors back to the 5 and 6 services, which interworked with each other. To publicise the move, a former London Transport Routemaster was hired for a week from East Yorkshire. I had the pleasure of driving it first, and what a great bus it was to drive. 808, VLT 188, is seen at Brankin Moor terminus with myself at the wheel. 25 May 1993. (J. Carter collection)

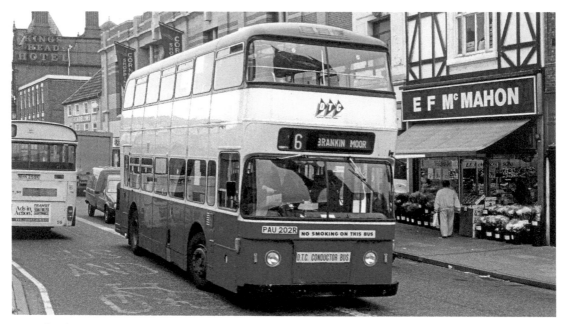

Fleetline 202, PAU 202R, is about to turn into Tubwell Row in the town centre. A new sign proclaims it as a 'DTC Conductor Bus'. While the conductor experiment proved popular with many passengers, it did not prove a financial success. 27 May 1993. (J. Carter)

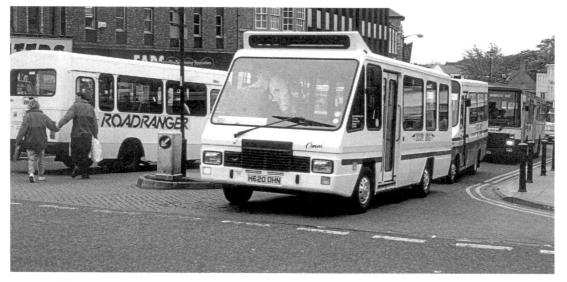

On this day, a new operator launched services on the streets of Darlington, and this would prove to be very bad news for DTC. Your Bus was formed by former United managers and they launched services on United Roadranger routes; United responded by increasing the frequency of their services and by flooding the town with duplicates, and DTC was caught in the middle of it all. A new CVE Omni of Your Bus is seen here, along with a second-hand Iveco minibus, two United Roadranger minibuses and, in the midst of it all, a DTC Dennis Dominator. 27 May 1993. (J. Carter)

The bus war was getting into full swing; this image illustrates the difficulty DTC drivers had in even accessing bus stops, particularly with full-sized buses. The council brought in a no-waiting rule on stops, but even so bus stop hogging was still commonplace. Pedestrians faced a difficult job when crossing the road and the local paper was full of letters from local residents complaining about the situation. 29 May 1993. (M. Harrington)

Towards the end of its stay with DTC, 808, VLT 188, is parked in Crown Street in the town centre. 30 May 1993. (J. Carter)

Dennis Dominator 14, GHN 814V, is just turning off Tubwell Row on its way to Harrowgate Hill on service 1. 14 June 1993. (J. Carter)

Fleetline 60, NHN 260K, is passing along Prebend Row in the town centre with the driver probably wondering if he was going to get on his stand just around the corner. The back of a Leyland Leopard of The Eden loading for a Dart service journey to Bishop Auckland can be seen. 14 June 1993. (J. Carter)

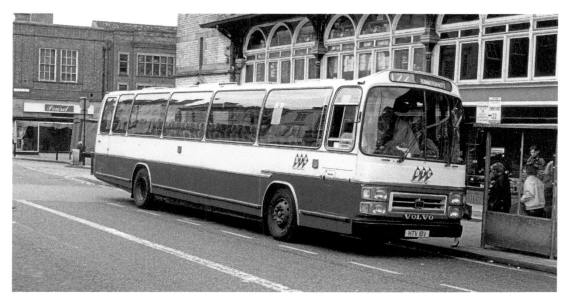

Bus 28, HTV 18V, is seen loading on service 122 to Hummersknott in one of the leafier parts of the west end of town. Prior to deregulation, Hummersknott was served by a half-hourly service, number 7, of the Corporation. Never a money spinner, it was deregistered at the start of deregulation with United picking it up under tender and incorporating it within its Roadranger minibus network as service 122. DTC later picked up a couple of teatime runs on tender but had to continue to use the Roadranger service number. 14 June 1993. (J. Carter)

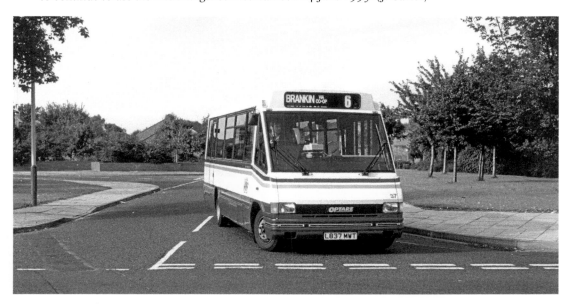

In September 1993, DTC took delivery of a batch of four Optare Metroriders, 37–40, L837–840 MWT. These four buses, along with the six earlier Metroriders, 31–36, were the only service buses bought new by DTC. Bus 37 is seen at the end of Bellburn Lane on a service 6, heading towards town. The destination screen advertises that the bus passes the new Co-op supermarket on Neasham Road. (M. Harrington)

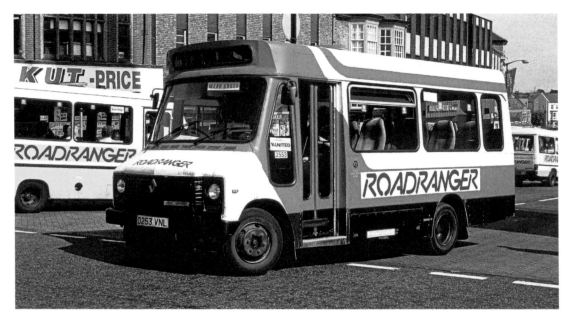

United were rapidly increasing their minibuses in the town. Some were transferred in from other depots or from sister company Tees & District. Further examples were hired in or were acquired. Wear Buses Alexander-bodied Dodge D263 VNL, United 2553, was hired in and across the road is an acquired Iveco minibus. All these extra buses were chipping away at DTC town service loadings; so much so that it seemed as if buses outnumbered passengers at this time. 30 August 1993. (M. Harrington)

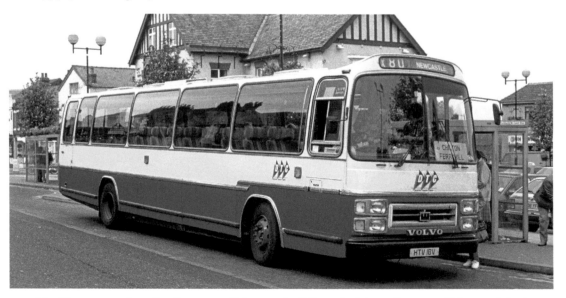

The X77 express from Darlington and Newton Aycliffe to the Metro Centre and Newcastle had proved popular. The opportunity was taken to introduce a variation, the X80, which also called at Chilton and Ferryhill. Bus 28 is seen picking up at Ferryhill on a quiet day. 18 September 1993. (M. Harrington)

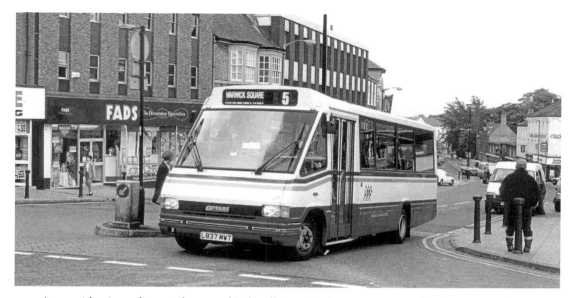

A nearside view of 37 at the top of Tubwell Row in the town centre, this time on service 5. By this time the 5 had extended from its traditional terminus of Faverdale to Warwick Square and was interworked with service 6, with buses changing from one to the other at Brankin Moor. 24 September 1993. (M. Harrington)

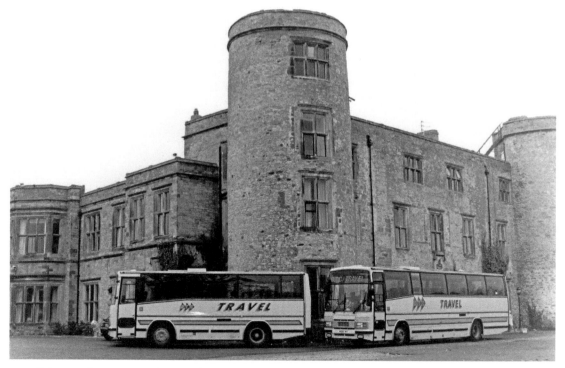

Taken in the autumn of 1993, this publicity picture features coaches 119 and 105 at Walworth Castle. (Geoff Gardner collection)

This MCW-bodied Leyland Fleetline, VCU 400T, DTC 200, was acquired from Busways. After briefly running in yellow, it was painted in this unusual scheme of blue and cream on one side, with DTC Travel on the other. Showing its split personality, it is seen in Red Hall Estate. 12 February 1994. (M. Harrington)

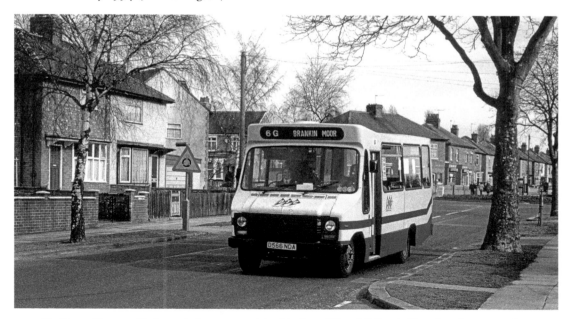

Six Reeve Burgess Dodge minibuses were hired in from West Midlands Travel and were used to launch service 6G. While mainly following the existing 5 and 6 service from the town centre to Brankin Moor, 6G diverted around Geneva Crescent, serving an area that was a little way off existing bus stops. D566 NDA, DTC 66, is heading along Park Lane towards Geneva Crescent. 12 February 1994. (M. Harrington)

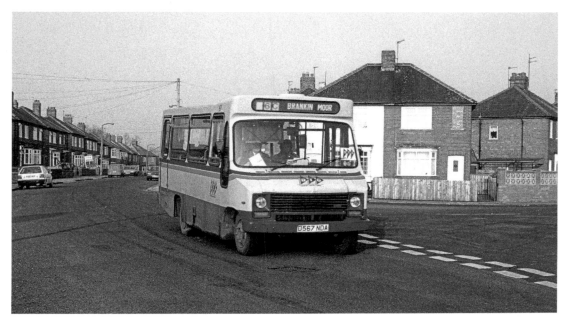

D567 NDA, DTC 67, displays the later blue and silver West Midlands livery and is seen in Geneva Crescent. 12 February 1994. (M. Harrington)

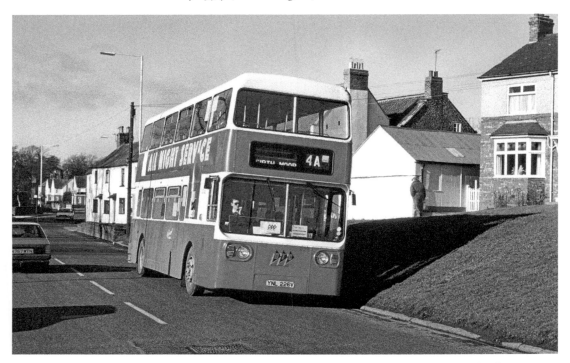

1994 was to prove to be DTC's final year, and during it there were many changes to the fleet. In this picture, YNL 226V, fleet number 226, is in Cockerton. This was an MCW-bodied Leyland Atlantean that was on loan from Wear Buses. February 1994. (M. Harrington)

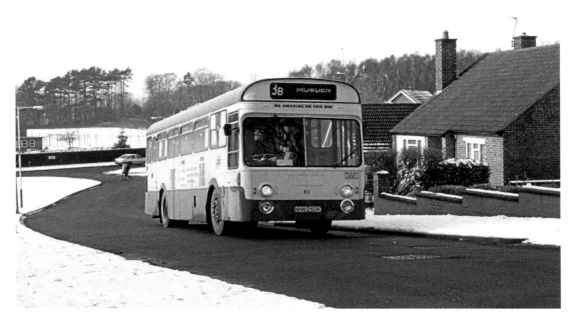

Fleetline 50, NHN 250K, is still happily alive and well in Darlington. In this view, 50 is climbing up Bylands Way in the Mowden area of town. The Mowden circular services had been altered to run this way, and thereby gave a service to the Hummersknott and Salutation Road area. 22 February 1994. (M. Harrington)

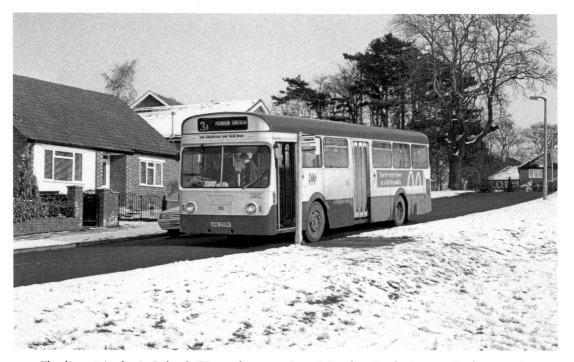

Fleetline 58 is also in Bylands Way and is operating a Mowden circular journey in the opposite direction. 22 February 1994. (M. Harrington)

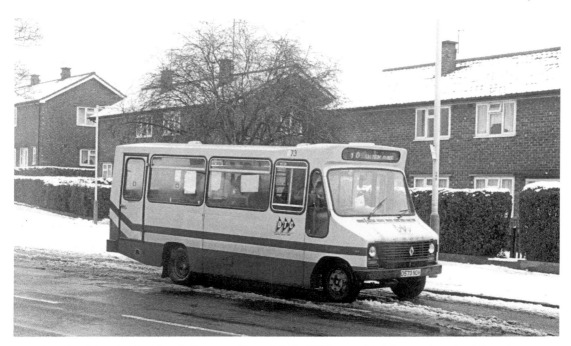

Another West Midlands minibus was D573 NDA, DTC 73, which is seen here in Salters Lane South. 26 February 1994. (J. Carter)

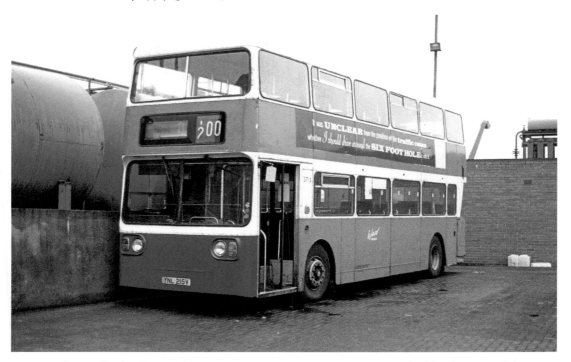

Another Leyland Atlantean from Wear Buses was YNL 215V. It received a blue front panel, but in the end, it was not used. It is seen here parked at the depot. 28 February 1994. (J. Carter)

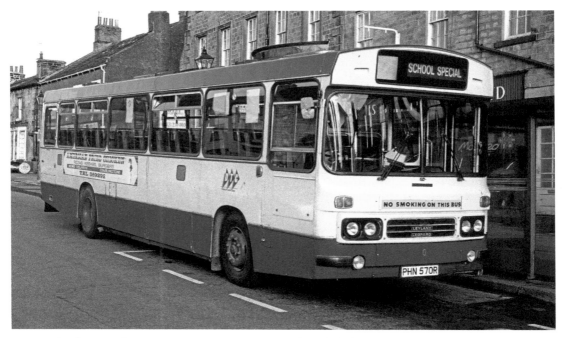

Leyland Leopard 70, PHN 570R, is seen at Barnard Castle before commencing a school contract from Barnard Castle School to villages in the Darlington area. 3 February 1994. (J. Carter)

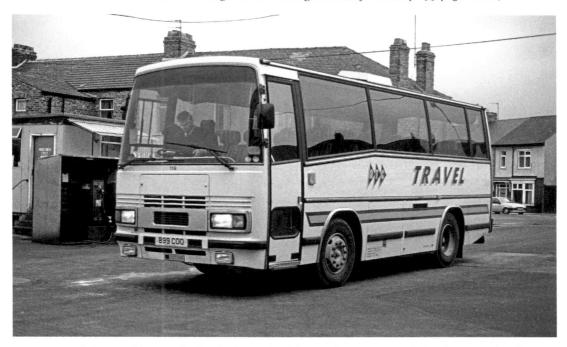

Some of the coaching stock that had remained in previous operators' liveries started to be painted into the Wallace Arnold-style DTC Travel livery. Ford R1115 119, B99 COO, is on the fuel pump at the depot. 4 February 1994. (J. Carter)

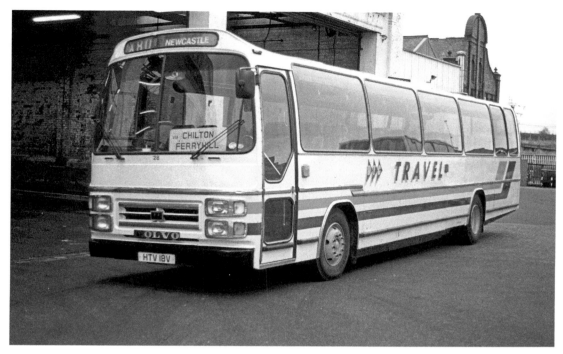

A surprising recipient of DTC Travel colours was Volvo B58 28, HTV 18V. It spent most of its time on stagecarriage express work, with the occasional hire work. 4 February 1994. (J. Carter)

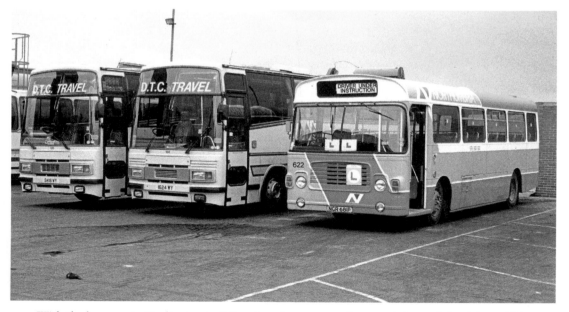

With the bus war in Darlington in full swing, there was an increased demand for drivers. This ECW Bristol LH, NGR 681P, was hired in from Northumbria Motor Services for driver training duties. It is seen parked at the depot along with B10M coaches 108 and 104. 4 February 1994. (J. Carter)

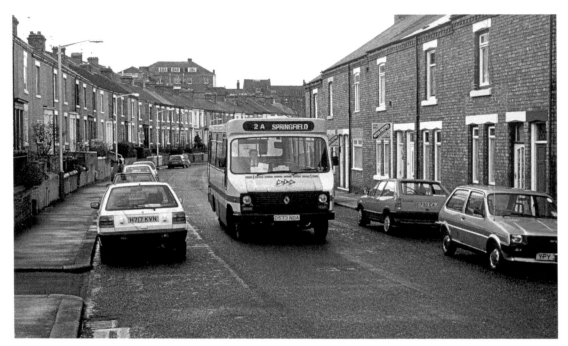

Dodge minibus D573 NDA, DTC 73, is heading along Hargreave Terrace, near the railway
station. A new service, 2A, operated along several roads that had been previously unserved by
DTC, including in Skerne Park, Springfield and on this road near the station. 12 February 1994.
(M. Harrington)

West Midlands minibus D578 NDA, DTC 78, and Leopard 69, PHN 569R, are passing the Civic
Theatre in Parkgate. 12 February 1994. (M. Harrington)

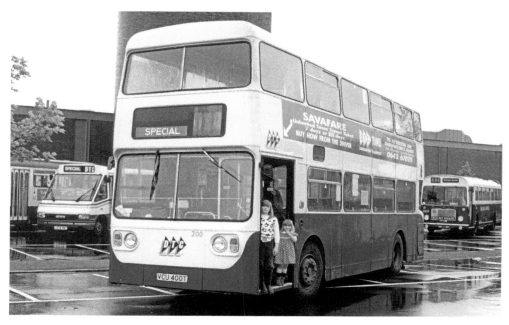

The Darlington bus rally was held in 1994, and bus 200, VCU 400T – an MCW-bodied Leyland Fleetline – was exhibited. The two little girls, daughters of DTC drivers, are now grown up with their own children. 13 February 1994. (J. Carter)

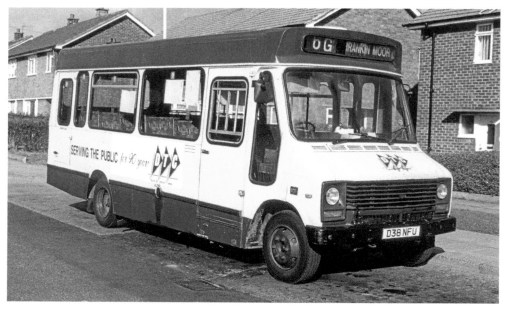

Two more hired in minibuses arrived on the scene; this time, it is two Alexander-bodied Dodges from Chester, D38 and D39 NFU, which were new to Grimsby Cleethorpes. DTC numbered them 44 and 45. 44 is seen at Brankin Moor Terminus and carries publicity to mark ninety years of DTC, and Darlington Corporation before it. Unfortunately, we wouldn't see a ninety-first year. 15 February 1994. (J. Carter)

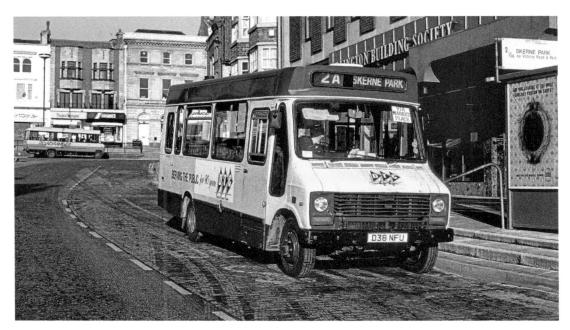

Hired in Chester, minibus 44 is again seen on Tubwell Row. In the background is a Roadranger minibus from United's sister company, Tees & District, which had been transferred to Darlington to increase United's fleet in the town. 19 February 1994. (M. Harrington)

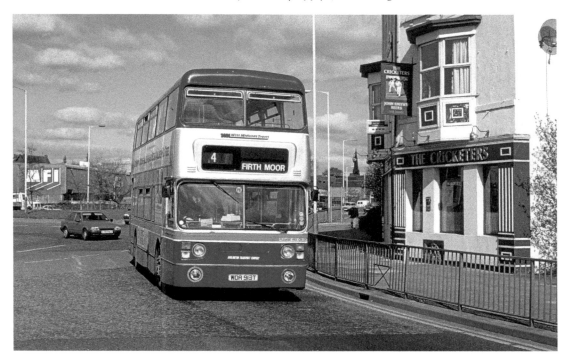

West Midlands Fleetline WDA 913T, DTC 213, is in the then latest WMT livery and has just crossed the ring road, heading into Parkgate. 26 February 1994. (M. Harrington)

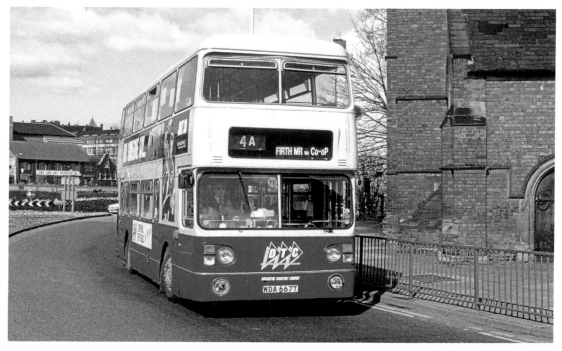

West Midlands Fleetline WDA 667T, DTC 217, is seen negotiating the same corner. 26 February 1994. (M. Harrington)

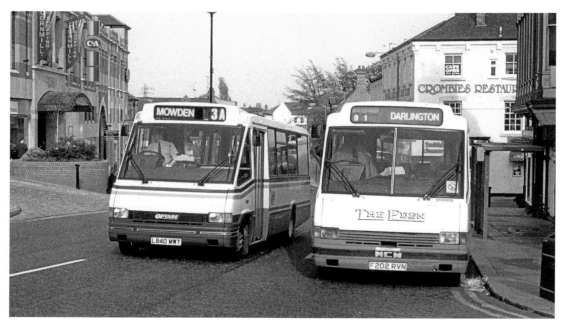

Optare Metrorider 40 is passing a similar MCW version of The Eden on a Dart service to Bishop Auckland. This particular stop, a common crew-change point, was known as Find-it-Out after the adjacent newsagent. 2 May 1994. (M. Harrington)

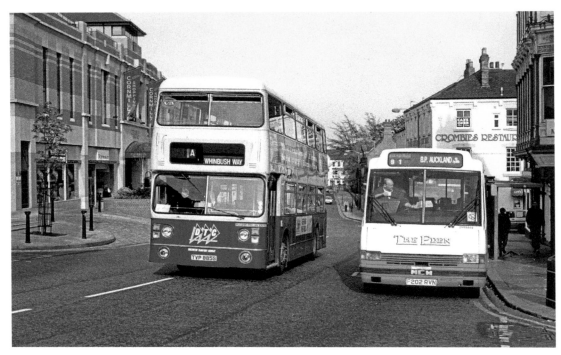

West Midlands Fleetline TVP 885S, DTC 215, passes the same The Eden Metrorider. 2 May 1994. (M. Harrington)

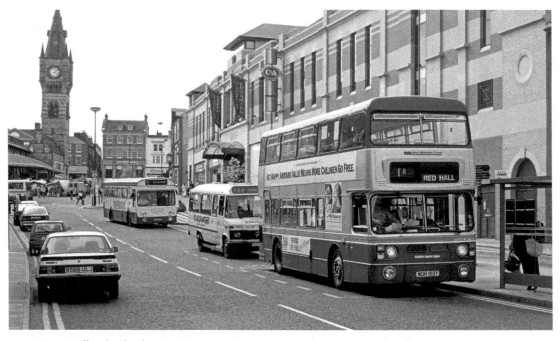

West Midlands Fleetline WDA 913T, DTC 213, is picking up on Tubwell Row. For once, DTCs outnumber Roadrangers. 5 May 1994. (M. Harrington)

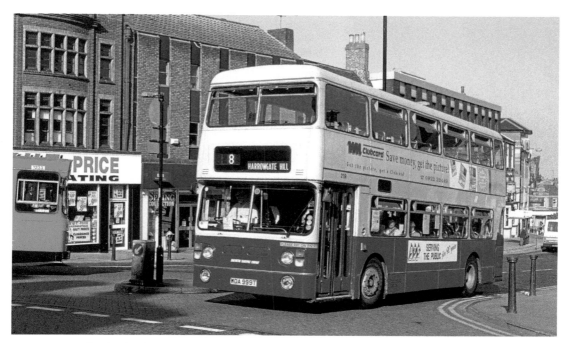

West Midlands Fleetline WDA 999T, DTC 219, is at the top of Tubwell Row. I picked this bus up from Perry Barr in Birmingham, which was followed by a long drive to Darlington at 35 mph. 12 May 1994. (M. Harrington)

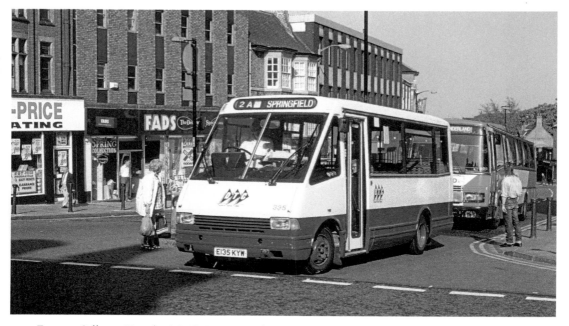

Former Selkent (London) MCW Metrorider E135 KYW, DTC 335, is seen on a 2A service towards Springfield. DTC had started buying second-hand Metroriders and this was one of the first into service. 13 May 1994. (M. Harrington)

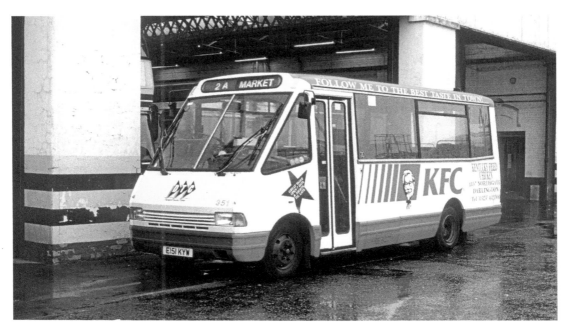

Ex-Selkent (London) E151 KYW, DTC 351, is at the depot in an advertisement livery. These acquisitions allowed some of the hired minibuses to return to their owners. 15 May 1994. (J. Carter)

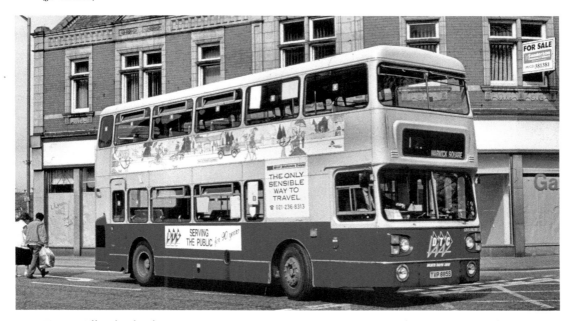

West Midlands Fleetline TVP 885S, DTC 215, is seen turning out of Crown Street. This bus was Park Royal-bodied rather than MCW-bodied, but was made to the same design. It is on the 12 to Warwick Square; this was another new route linking the Warwick Square and Nickstream Lane area with Cockerton and the hospital on the way to and from town. 15 May 1994. (M. Harrington)

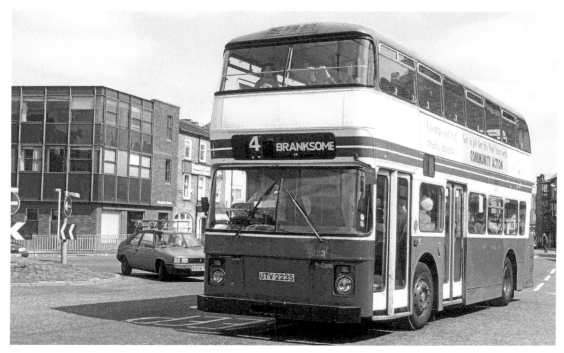

Nottingham Fleetline UTV 223S, DTC 223, is leaving the town along Bondgate. 26 May 1994. (M. Harrington)

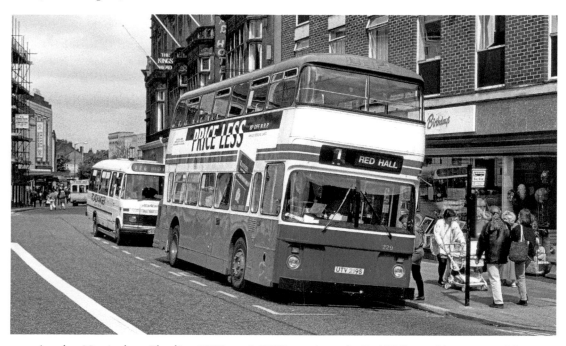

Another Nottingham Fleetline, UTV 219S, DTC 229, is on the Red Hall stand in town. 26 May 1994. (M. Harrington)

The fleet was rapidly changing; the Seddons had already gone, the Dennis Dominators were finished, and even the more youthful Ward Dalesmans had been sold. Nearly all of the former Watson and Rydal vehicles had been sold too. A more surprising disposal was Leyland Leopard 22, VRM 622S. Painted for new owner Gibson of Moffat and given a set of second-hand seats, it is seen at the depot before its departure to pastures new. 26 May 1994. (J. Carter)

DTC was awarded a Dalesbus contract in 1994. Volvo B58 29, GPH 2V, is at Bainbridge, in Wensleydale. 29 May 1994. (J. Carter)

29 is seen again, but this time in Hawes at the Yorkshire Dales National Park Centre, which is based at the old railway station. 29 May 1994. (J. Carter)

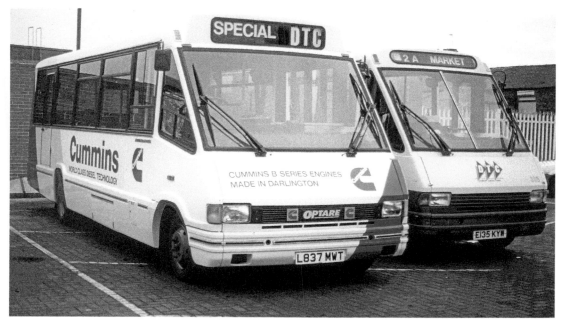

Optare Metrorider 37 was chosen to carry this livery for Cummins, who have a plant in Darlington. The Metroriders were powered with Darlington-built Cummins engines. Parked next to it at the depot is a recently acquired ex-Selkent MCW Metrorider, E135 KYW, DTC 335. 11 June 1994. (J. Carter)

Another acquired coach, in 1993, was this Leyland Tiger with an ECW body. This had been new to London Country for Green Line work, but DTC acquired it more locally from Robson of Stockton, becoming DTC 12. It is seen here in Fleetwood during the annual trip to Tram Sunday and Blackpool. 17 July 1994. (J. Carter)

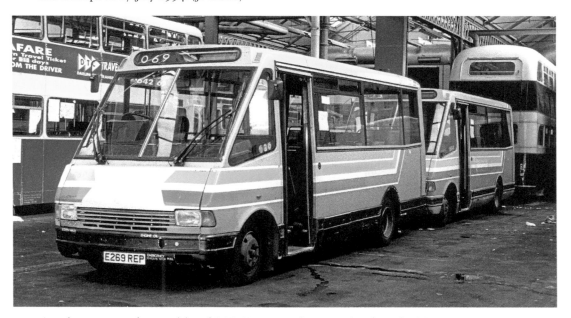

Another source of second-hand MCW Metroriders was South Wales Transport. Five were acquired and two of them are seen awaiting preparation at the depot with E269 REP, DTC 369, in front. A privately preserved vehicle is receiving attention in the background. 29 August 1994. (J. Carter)

Bus 200 went to the annual bus rally held at Seaburn, Sunderland, and it is seen parked next to a Northumbria Alexander-bodied Fleetline. Both buses were new to Tyne & Wear PTE and served in Sunderland. Stagecoach also transferred ex-Sunderland Fleetlines to Darlington to help launch its infamous foray into the town. 29 August 1994. (J. Carter)

Ex-South Wales Metrorider E278 REP, DTC 378, is parked outside the Nags Head pub in Tubwell Row. 1 September 1994. (M. Harrington)

Further acquisitions included seven Leyland Leopards with Plaxton Derwent bus bodies. They had been new to Lancashire United, but were acquired from Busways and arrived in DTC livery. LTE 494P, DTC 419, is at the top of Tubwell Row and about to commence a Dart service to Newton Aycliffe. 17 September 1994. (M. Harrington)

Leyland Leopard LTE 494P, DTC 419 is heading into town along North Road and has just passed the Brougham Street stop. Leyland Fleetline UTV 210S, DTC 210, is picking up. 210 was the only one of the S-registered batch of Fleetlines that DTC acquired rather than just hired. 17 September 1994. (M. Harrington)

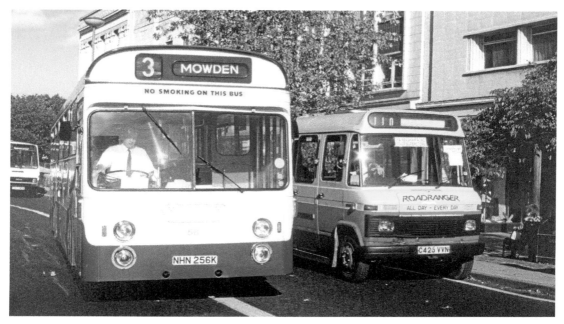

Despite the influx of newer vehicles, some of the oldest Fleetlines kept plodding along. 56 is overtaking a former Tees & District minibus in Northgate in the town centre on yet another new service in the town, and bits of paper in the windscreen provide information on the route. A Your Bus minibus is behind. 30 September 1994. (M. Harrington)

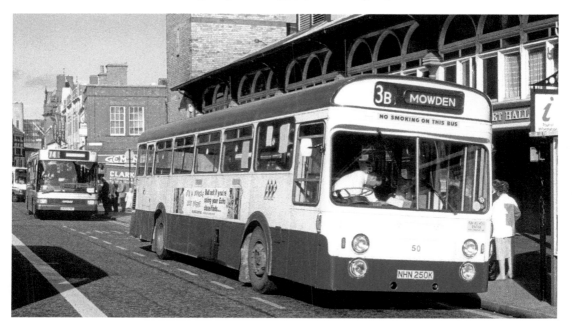

Fleetline 50 is picking up outside the Covered Market in Darlington on a Mowden Circular town service. An Optare Vecta demonstrator with United is in the background. 30 September 1994. (M. Harrington)

As the bus war intensified, DTC introduced service 22 and 22A. This operated from Ferryhill, through Chilton, Newton Aycliffe, Darlington, Richmond and Catterick Garrison to Colburn and competed against several of United's best routes. An ex-South Wales Metrorider on a 22A, E262 REP, DTC 362, is alongside Leopard 21, VRM 621S, which is on the 37 in Richmond. 3 October 1994. (J. Carter)

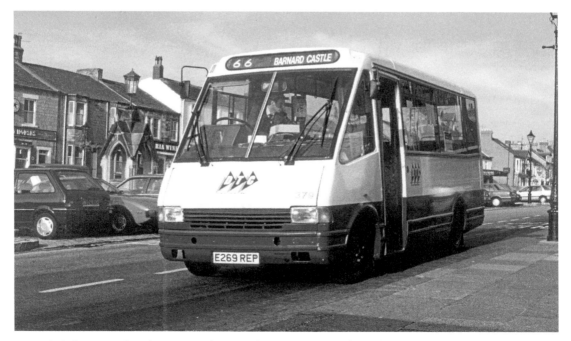

DTC then introduced service 66 from Darlington to Barnard Castle. On the first day of the new service, Metrorider 379 is in Barnard Castle. 3 October 1994. (J. Carter)

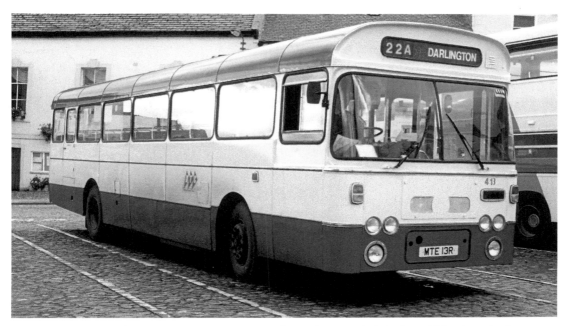

Leyland Leopard MTE 13R, DTC 413, is at Richmond on a 22A. It looks as if the depot had run out of 3s when applying the fleet number and an 8 cut in half had to suffice. 3 October 1994. (J. Carter)

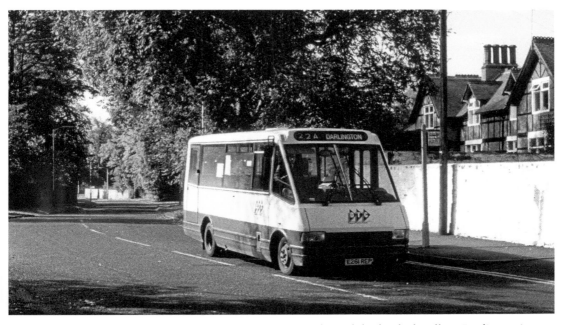

Another Metrorider, E261 REP, DTC 361, is passing through leafy Blackwell on Darlington's western outskirts. These ex-South Wales buses had manual transmission rather than the far more common automatic. They were nicer to drive and much faster on the open road. 4 October 1994. (M. Harrington)

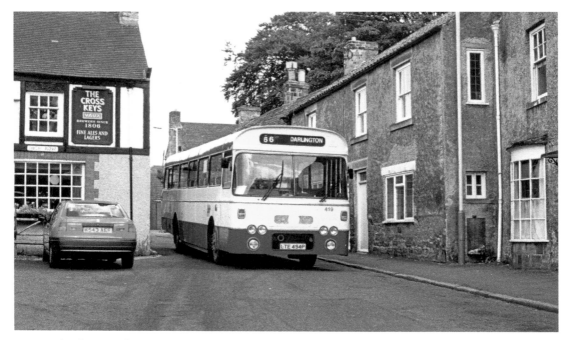

Leyland Leopard LTE 494P, DTC 419, is at Gainford on a 66 from Barnard Castle to Darlington. 8 October 1994. (M. Harrington)

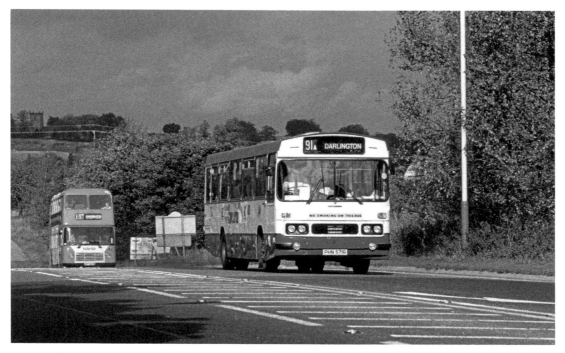

Leyland Leopard 71, PHN 571R, is climbing up to Coatham Mundeville on a Dart service. A United Bristol VR, APT 808W, is in pursuit. 8 October 1994. (M. Harrington)

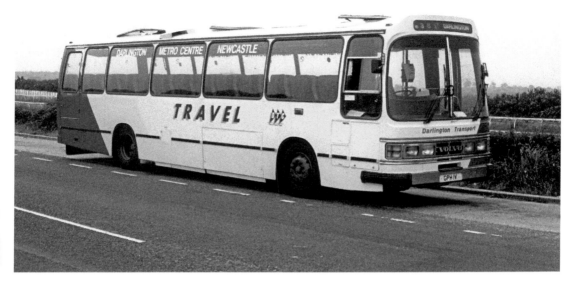

Duple Dominant bodies were known for their corrosion problems and Volvo B58 26 is seen here having emerged from a body overhaul. The seats had been trimmed and she wore a new version of the livery with light blue skirts. Sadly, DTC wouldn't benefit for very long from all this work. She is parked next to Catterick Racecourse after completing the Saturday through journey from Newcastle. 9 October 1994. (J. Carter)

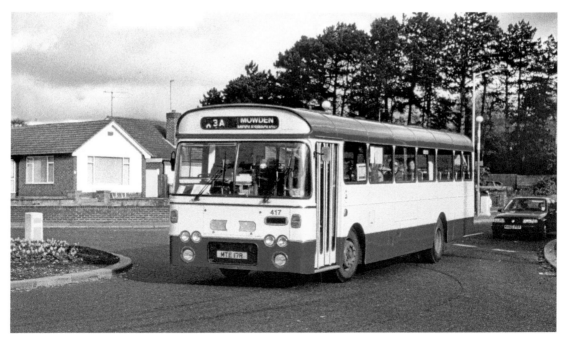

Leyland Leopard MTE 17R, DTC 417, is seen rounding Elm Ridge roundabout on Coniscliffe Road on town service 3 to Mowden. 2 November 1994. (M. Harrington)

MCW Metrorider E149 KYW, DTC 349, is picking up at Mowden Shops. This was the first day of Stagecoach running their free services and a Mercedes minibuses is overtaking. 7 November 1994. (M. Harrington)

On DTC's last full day of trading, stalwart Fleetline 56 is seen in Mowden Estate. The mood of the last few days was matched by the weather. 10 November 1994. (M. Harrington)

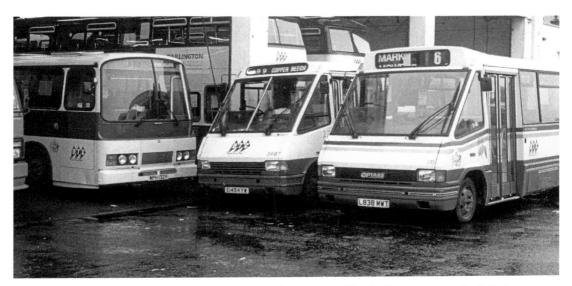

DTC's administrators took over on 11 November 1994 and by the late morning all of the buses had been recalled to the depot. In this picture, which was taken the following day, Leyland Tiger 12 and two Metroriders, 349 and 38, await their fate. 349 displays another new and short-lived service on its screen, the 99, which ran between the Copper Beech pub on Neasham Road and the Darlington Memorial Hospital entrance via the town centre. 12 November 1994. (M. Harrington)

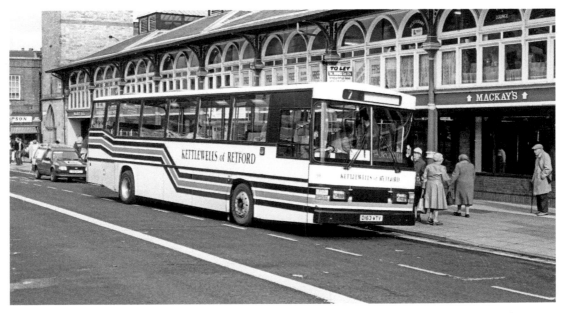

The next few pictures illustrate some of the demonstrators that DTC sampled. One of the first was this Scania K92 with East Lancs bodywork from the Kettlewell's of Retford fleet. For drivers more used to the plodding charms of Fleetlines, this bus had rapid acceleration, and during its trial there were probably a few old ladies who found themselves sitting a bit further down the bus than they had intended. 7 October 1987. (J. Carter)

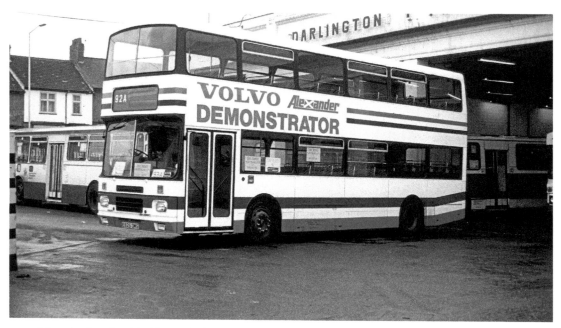

After the Scania, this Alexander-bodied Volvo Citybus, E825 OMS, was used. The bus was put to work on the Dart service between Darlington and Newton Aycliffe. A very pleasant bus to drive, it was later acquired by Nottingham City Transport and enjoyed a lengthy career with that operator. The picture was taken at the depot on 13 December 1987. (J. Carter)

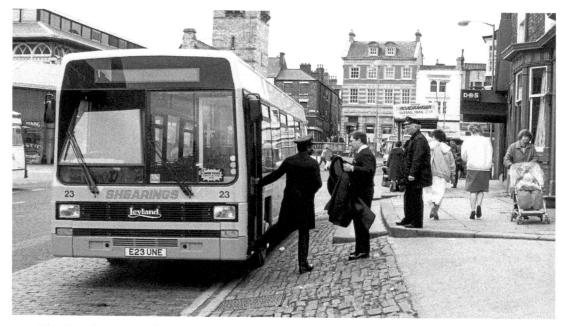

This Shearings Leyland Lynx, E23 UNE, was inspected but not used in service. The bus is parked in Tubwell Row in town while a DTC Inspector and the Traffic Manager look on. A United Inspector is also having a look. 9 February 1988. (J. Carter)

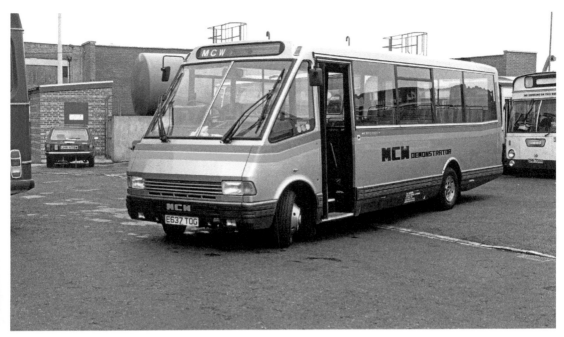

E637 TOG was an MCW Metrorider and was one of two in 1988. Later that year, DTC took delivery of six new Metroriders, E31–6 NEF. The picture was taken at the depot. 29 May 1988. (J. Carter)

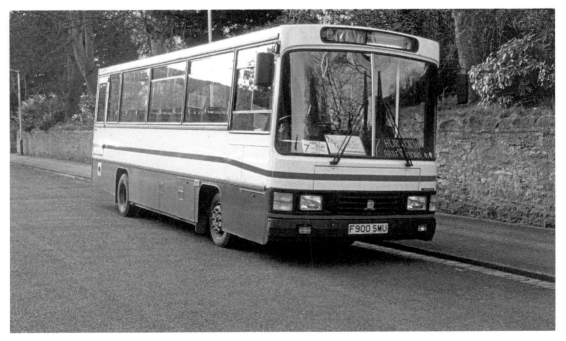

F900 SMU was a Wadham Stringer-bodied Leyland Swift. The entrance was steep and not particularly well suited to town service work. The bus was used on service 7, and this time the picture is in Milbank Road. 15 February 1989. (J. Carter)

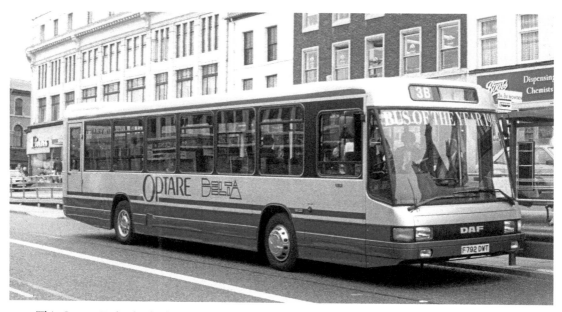

This Optare Delta-bodied DAF SB220, F792 DWT, was a more striking bus. They were certainly head-turners when they were first introduced. F792 DWT was used on the Mowden circular route, where the above-average number of elderly passengers would have appreciated the low and easy entrance. 3 October 1989. (M. Harrington)

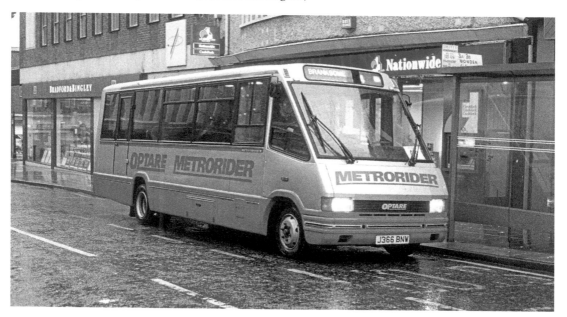

By now the Metrorider was produced by Optare, and was an improved version of the original. This Optare version, J366 BNW, was trialled on the 4 and 4A service between the Firth Moor and Branksome. The picture was taken on Bondgate in the town centre, from where the bus is headed for Branksome. A successful demonstrator, four Optare Metroriders were added to the fleet a few months later. 22 November 1992. (J. Carter)

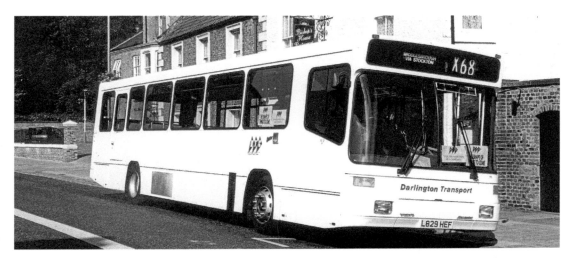

The final demonstrator used was this Alexander-bodied Volvo B10B, L829 HEF. It is about to operate an X68 journey to Stockton and Middlesbrough. This was the popular shoppers' service that ran on Wednesdays and Saturdays (Stockton market days). The posters boast of it being 'the shape of things to come'. With DTC up for sale, there was optimism that the company would pass to someone with the financial muscle to invest in the fleet and fight back against the intense competition that it was facing. The streets of Darlington did see a fleet of new Alexander-bodied Volvos by the end of the year. Unfortunately, they were B6s wearing the stripes of Stagecoach, and appeared a few weeks after DTC's demise. 13 August 1994. (J. Carter)

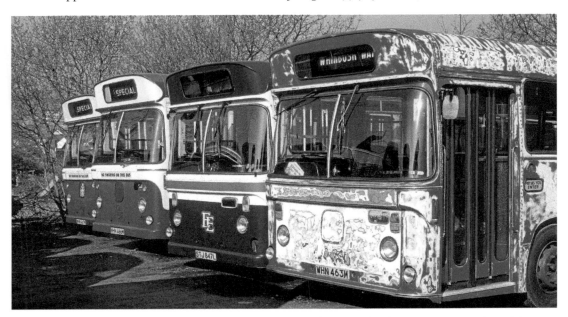

The next few pictures illustrate some of DTC's former buses with subsequent owners. Six of the eight Seddon RUs passed to RU-lover (there weren't many) East End Coaches of Clydach, South Wales. Former DTC 63, 66 and 67, WHN 463, 6 and 7M, are seen with a former Lytham Seddon RU, STJ 847L. 63 has been rubbed down to remove her former all-over advertisement livery. 66 and 67 were used for spares. 11 April 1992. (J. Carter)

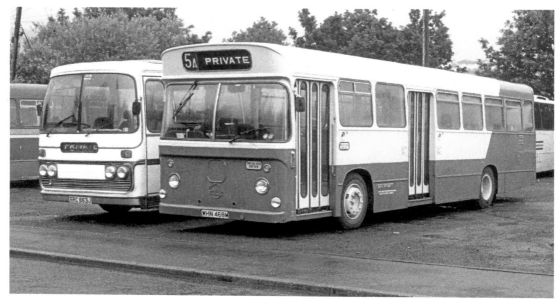

A visit to the East End Coaches premises the following year revealed former DTC 68, WHN 468M, which had been repainted into a green and cream livery. She sits next to ERC 883J, a Bedford YRQ with Plaxton bodywork that was new to Trent. 13 July 1993. (J. Carter)

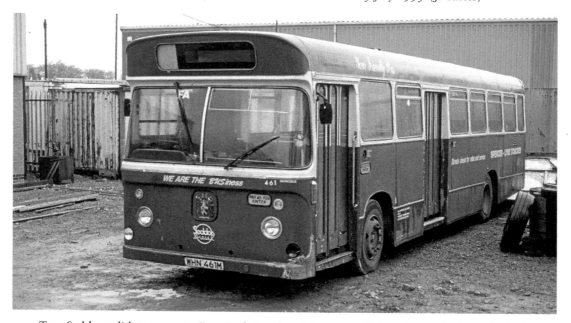

Two Seddons did not pass to East End Coaches. They were slightly later withdrawals, both carrying all-over advertisement liveries. One of those, DTC 61, WHN 461M, passed to Metrowest in the West Midlands, before later passing to Hopkinson of Market Harborough, and it is with them that it is seen here looking rather sorry for itself. The livery is still the dark green of Metrowest, and areas of her last orange-based advert livery with DTC are showing through. Strangely, she still displays the Darlington town crest too. 28 February 1994. (J. Carter)

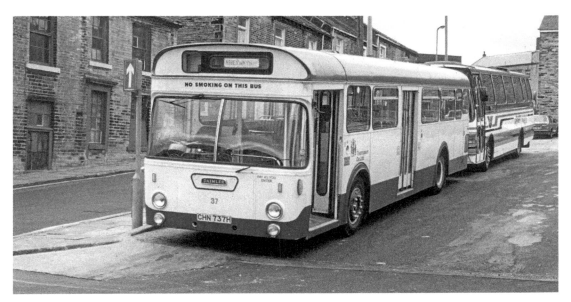

DTC 37, Fleetline CHN 737H, is seen with Abbeyways in Halifax on 14 September 1988. Not having been altered very much from her DTC days, only the Darlington part of the fleet name has been removed. This batch of twelve Marshall-bodied Daimler Fleetlines, CHN 737–48H, were new in 1970 to Darlington Borough Transport. Eight of the batch survived to DTC days and were replaced from September 1988, largely by the new MCW Metroriders, E31–6 NEF. (J. Carter)

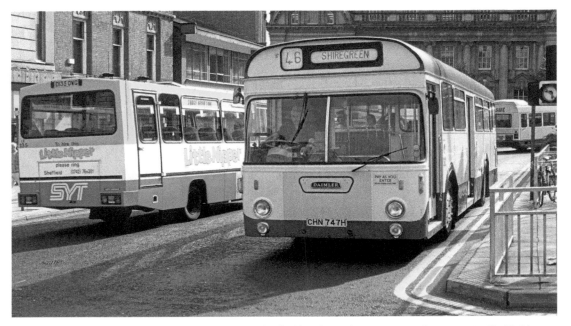

DTC 47, Fleetline CHN 747H, passed to a Sheffield independent, Groves. She is seen in Sheffield city centre with rather crudely made destination and service number blinds and only a yellow panel having been added to her Darlington colours. 25 September 1989. (J. Carter)

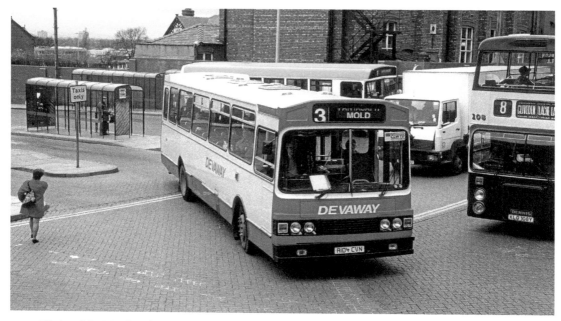

All six of the Ward Dalesmans were withdrawn in early 1994 and passed to Cheshire independent Devaway. The former DTC 4, A104 CVN, is seen leaving Chester bus station on a cross-border journey to Mold. 11 February 1994. (J. Carter)

Ex-South Wales Metrorider E268 REP, 378, served with North Yorkshire County Council after DTC. She is seen at Muker. Her regular run was on schools work into Richmond. As can be seen, full DTC livery, including fleet names, was still carried. 21 January 1995. (M. Harrington)

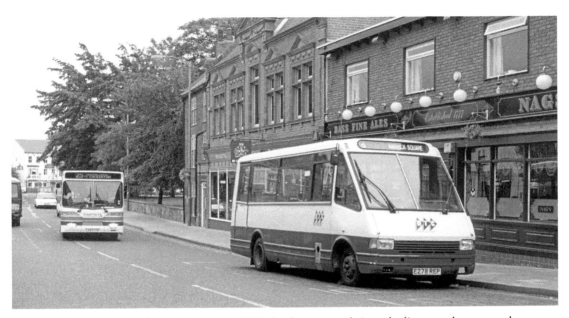

Nearly ten months after the demise of DTC, the former 378 brings the livery and company logo back to the streets of Darlington. Somebody has even set the screens to an appropriate service number and destination. She must have turned a few heads, with townsfolk wondering if DTC has arisen from the grave. 1 September 1995. (M. Harrington)

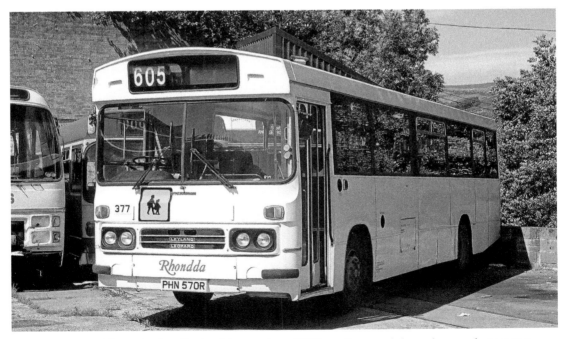

My personal favourite bus, Leyland Leopard 70, PHN 570R, passed through several operators after DTC. She is seen here during a brief period of serving with Rhondda at their Porth depot in 1997. (Phil Baldwin)

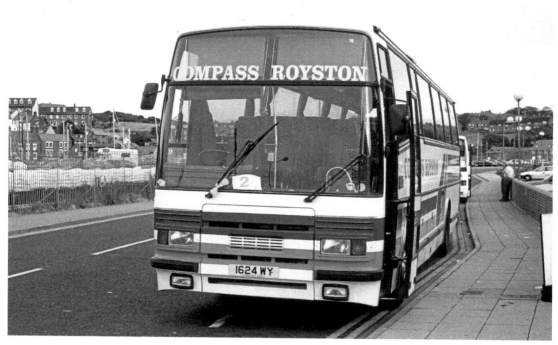

Two of the three ex-Wallace Arnold Volvo B10Ms passed locally to Compass Royston at Stockton. Former DTC 104, 1624 WY, is seen at Whitby. 16 July 1995. (J. Carter)

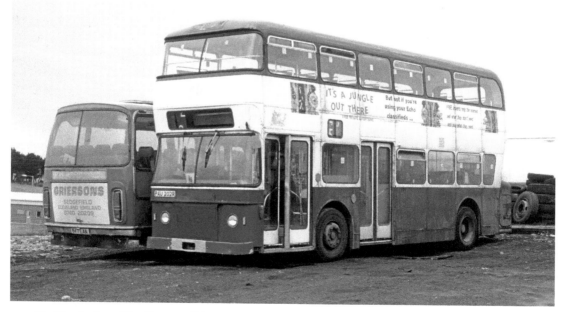

Ex-Nottingham Fleetline 202, PAU 202R, passed to local operator Grierson's of Fishburn. She is seen, looking a little careworn but otherwise little altered from DTC days, in her owner's yard. 30 February 1996. (J. Carter)

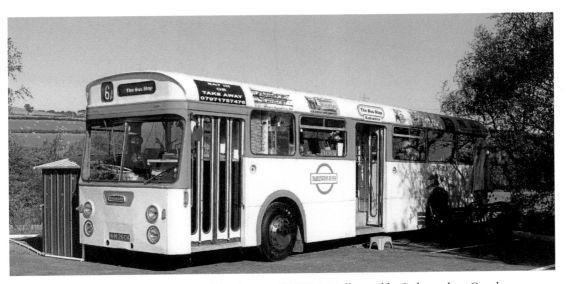

Fleetline 60, NHN 260K, survived the demise of DTC. Initially used by Independent Coachways of Horsforth, it passed through a number of preservationist hands before returning to the North East and being converted to a café. She is parked here in the village of Esh Winning. The livery is a rough approximation of the original livery that was carried by the bus when new. 26 September 2014. (J. Carter)

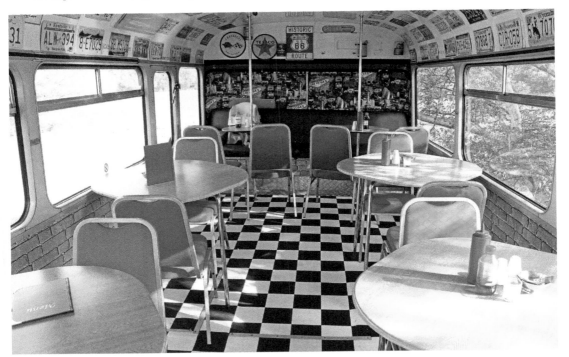

An internal view of Fleetline 60, NHN 260K, showing its American diner-style interior. Sadly, the business did not prove viable, and 60 faces an uncertain future. The owner kindly donated some interior fittings to its preserved sister bus, 50. 26 September 2014. (J. Carter)

Metrorider 37, L837 MWT, became available in 2016. A group of ex-staff members acquired it. However, despite its reasonable external appearance, it had severe corrosion underneath. The sad decision was taken to dispose of it, and at the time of writing it is stored at Gardiner's of Spennymoor in the hope that someone with the skills and facilities to take it on may come forward. The picture was taken at Enterprise Travel in Darlington, which had kindly offered it accommodation at the time. 31 May 2016. (J. Carter)

The only bus that served with DTC in preservation, to the best of my knowledge, is bus 50, NHN 250K, a Roe-bodied Daimler Fleetline. She is currently owned by Darlington-based Bus 50 Group, which includes a number of former employees, and is presented in her original livery. In this view she is seen in Kirkby Stephen while participating in the Kirkby Stephen & Brough Classic Commercial Vehicle Rally, which is held each Easter weekend. 27 March 2016. (J. Carter)